P9-EDO-509

A TIBETAN JOURNAL

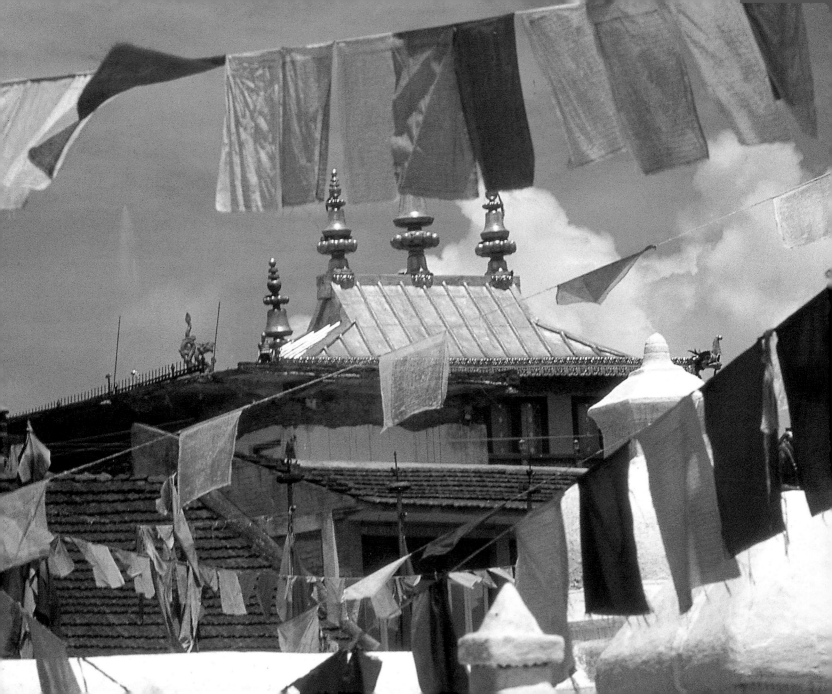

A TIBETAN JOURNAL

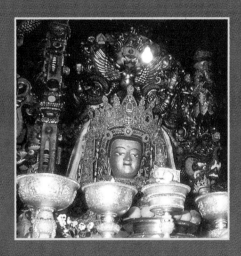

PHOTOGRAPHS BY
FIONA McDOUGALL

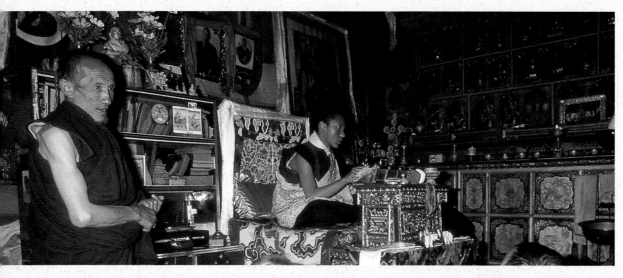

Copyright © 2000 by Fiona McDougall / OneWorld Photo™, of OneWorld
Communications, San Francisco. All rights reserved. No part of this book
may be reproduced or transmitted in any form or by any means, electronic
or mechanical, including photocopying, recording, or by any information
storage or retrieval system, except for brief review, without the express per-
mission of the publisher. For further information, you may write to:

CELESTIALARTS

P.O. Box 7123
Berkeley, California 94707

Celestial Arts titles are distributed in Canada by Ten Speed Canada, in the
United Kingdom and Europe by Airlift Books, in South Africa by Real Books,
in Australia by Simon & Schuster Australia, in New Zealand by Southern
Publishers Group, and in Southeast Asia by Berkeley Books.

Cover and text design by Greene Design

Printed in Singapore

1 2 3 4 5 6 / 05 04 03 02 01 00

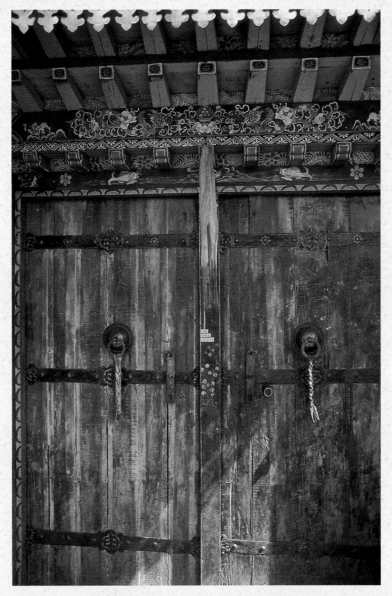

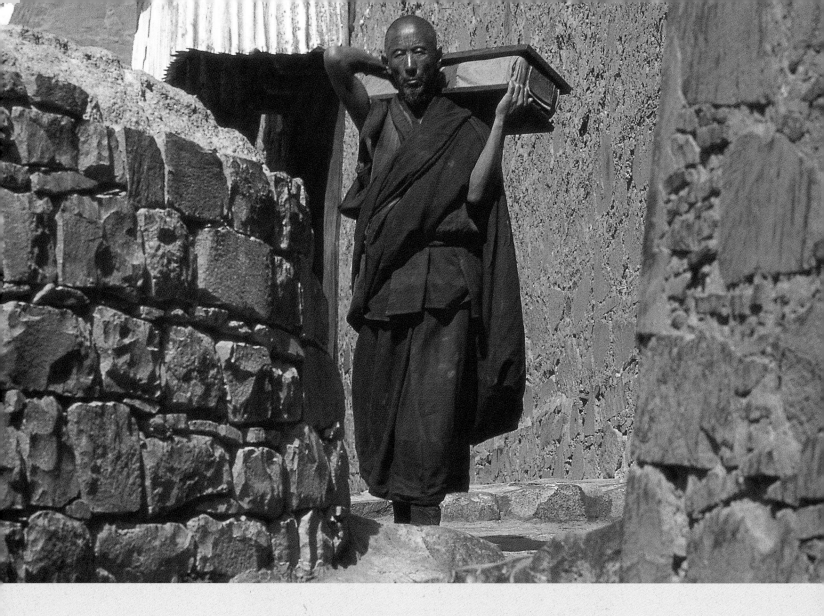

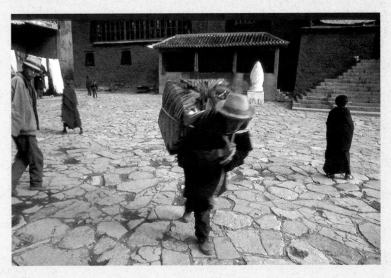

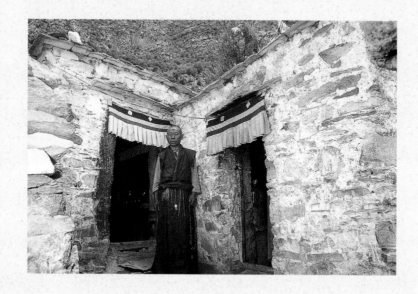

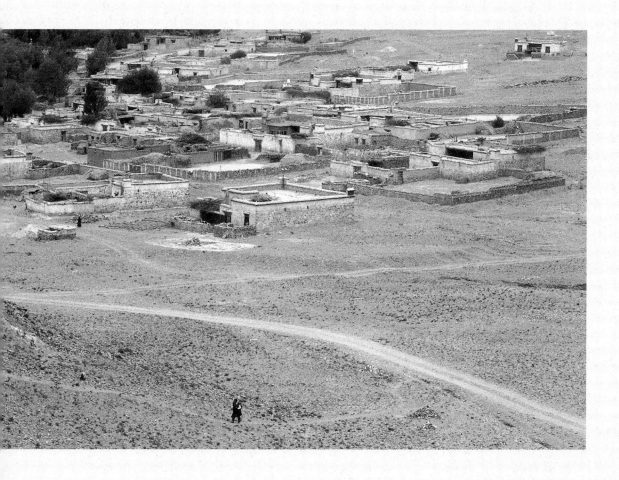

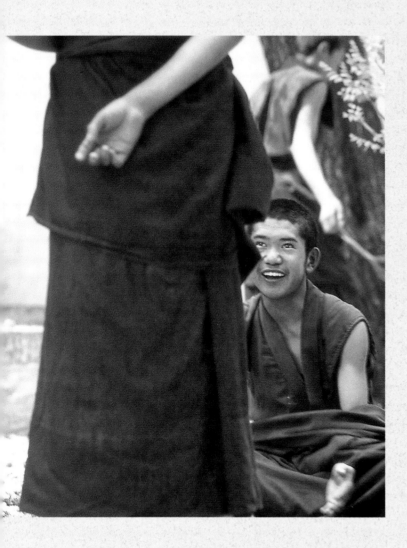

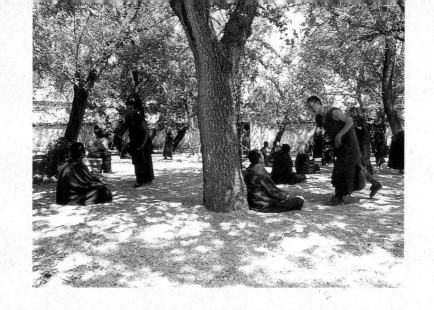

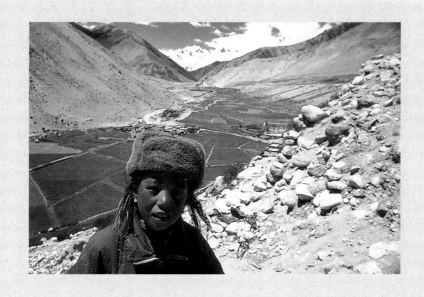

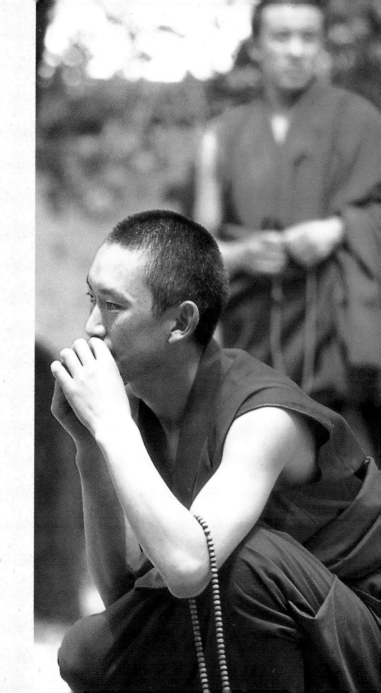

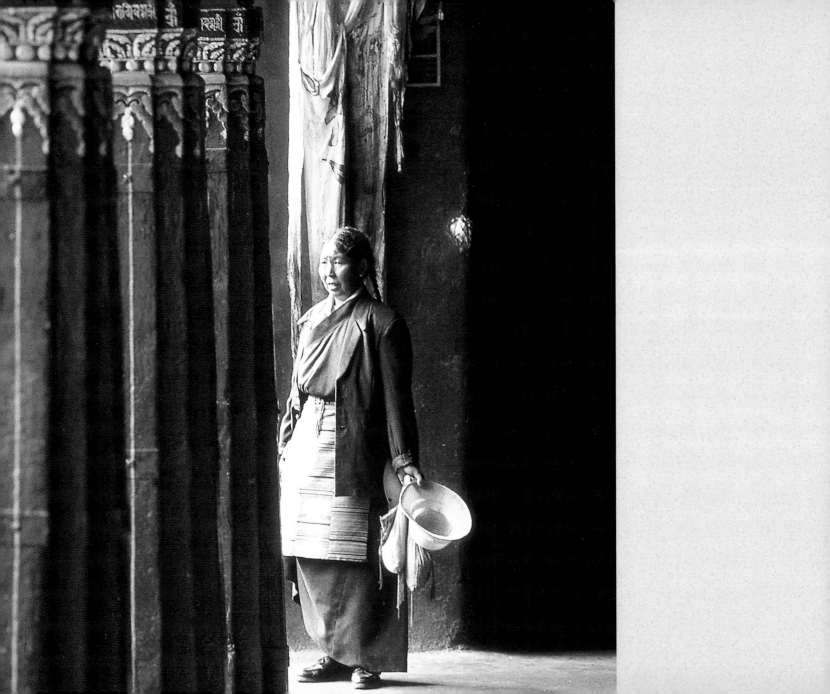

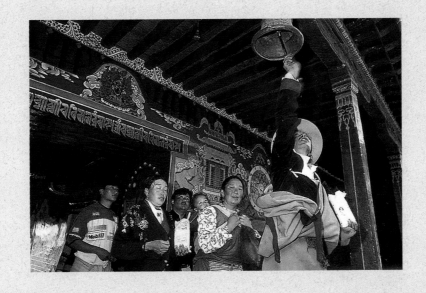

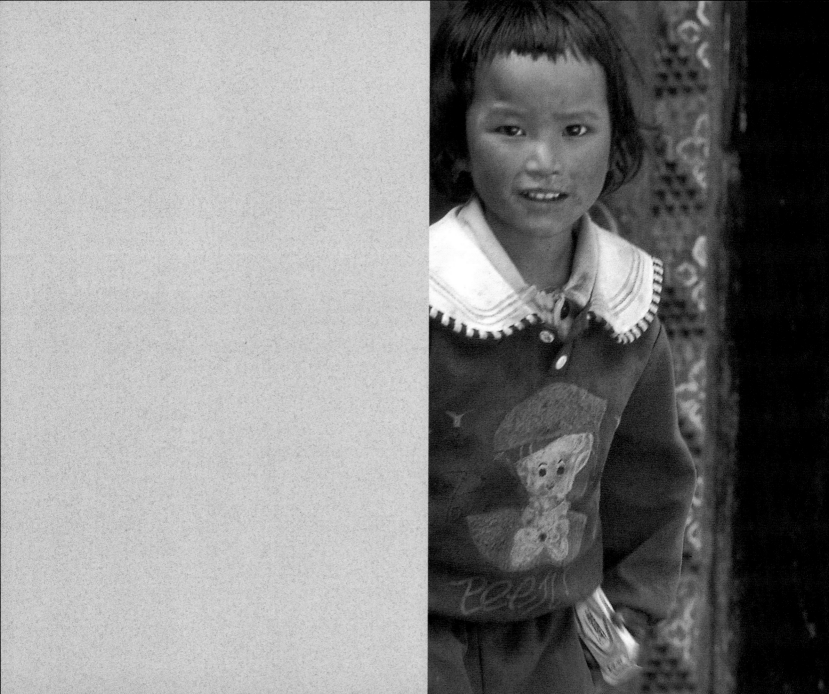

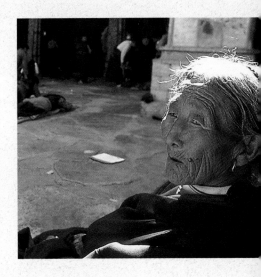

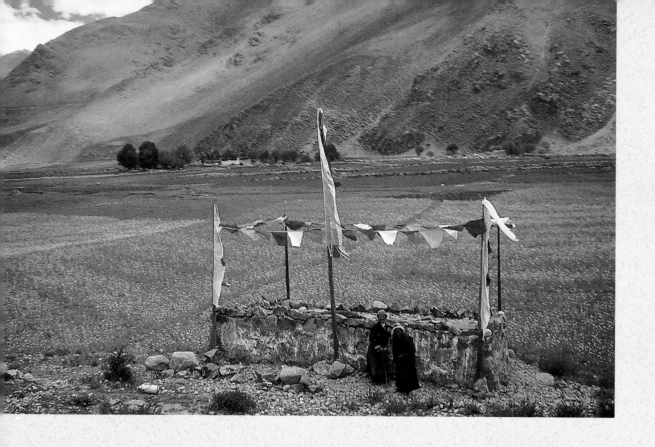

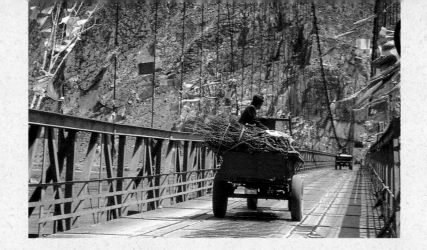

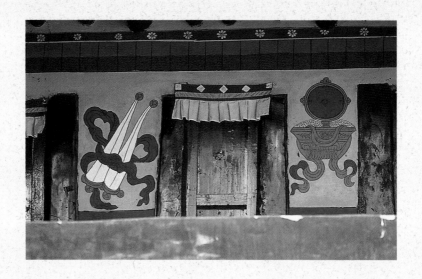

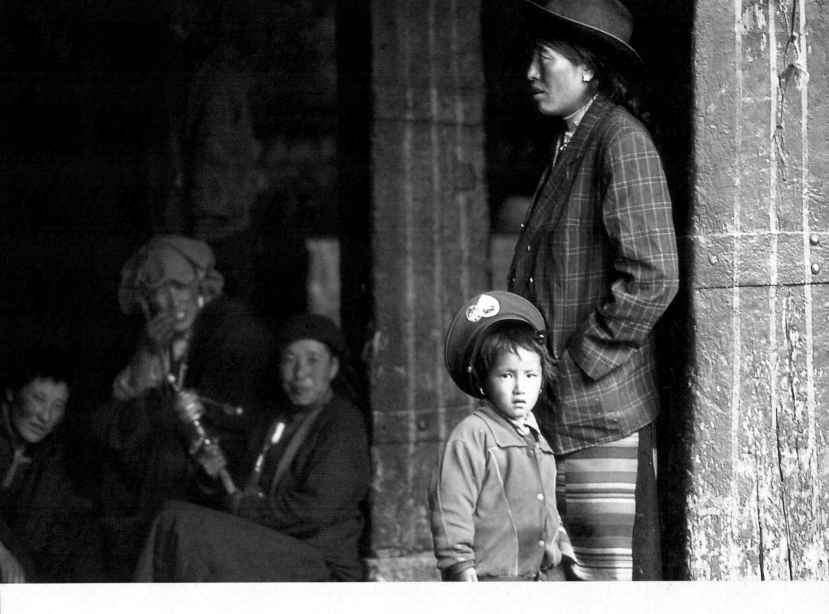

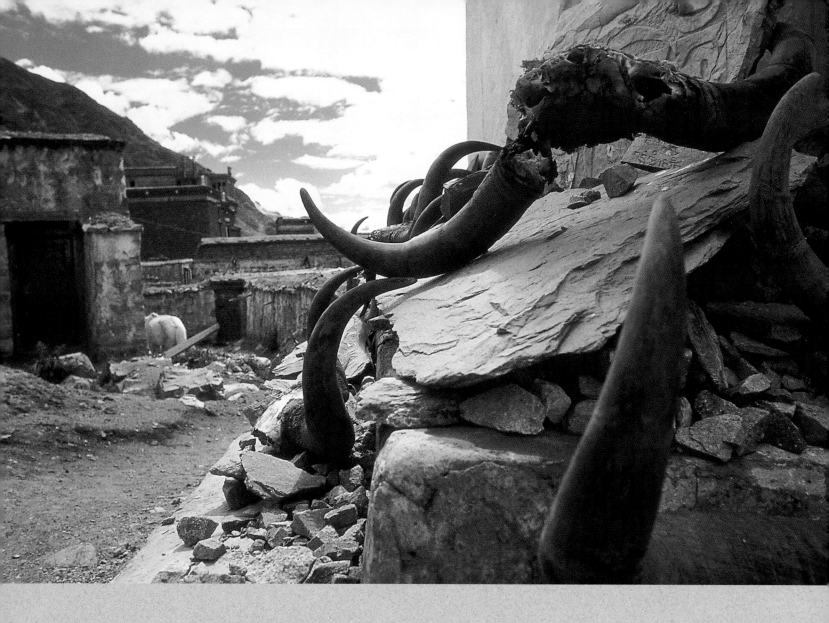

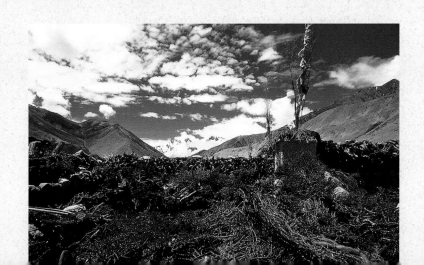

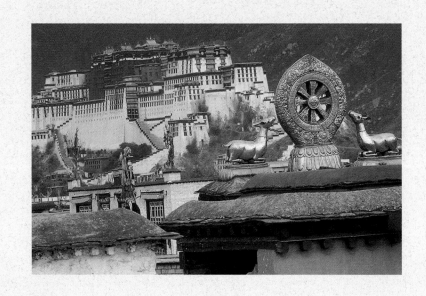

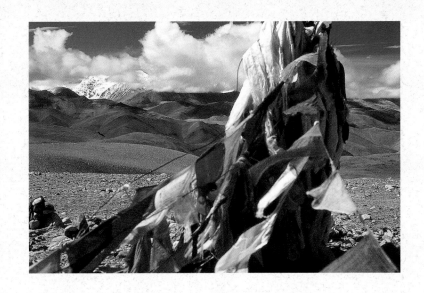

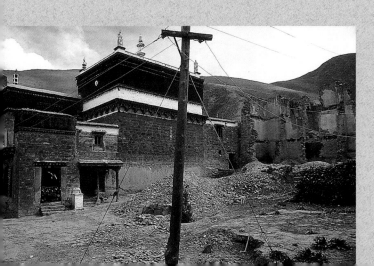

28

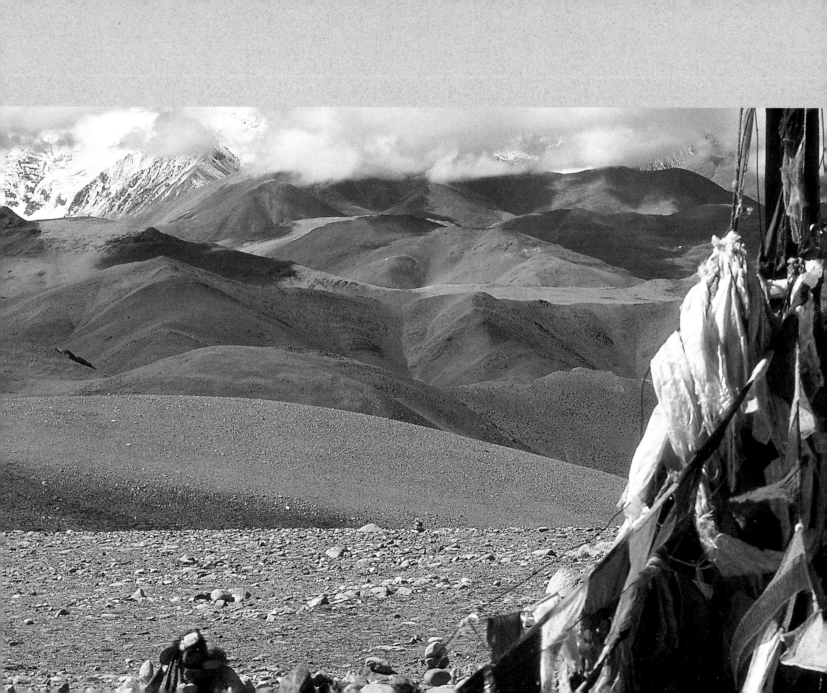

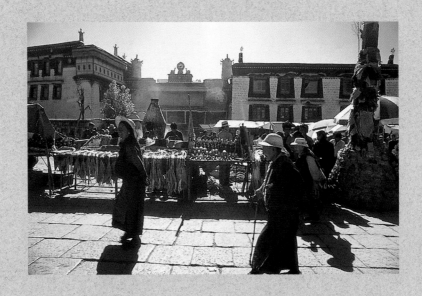

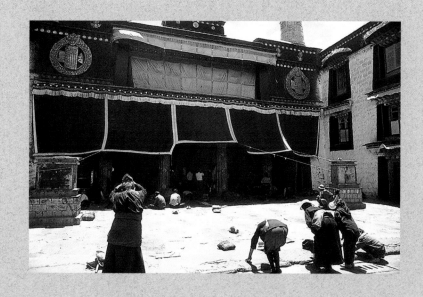

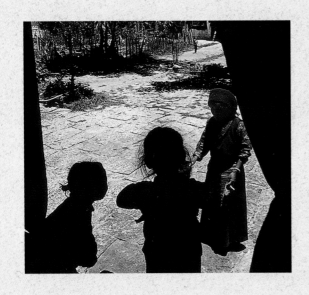

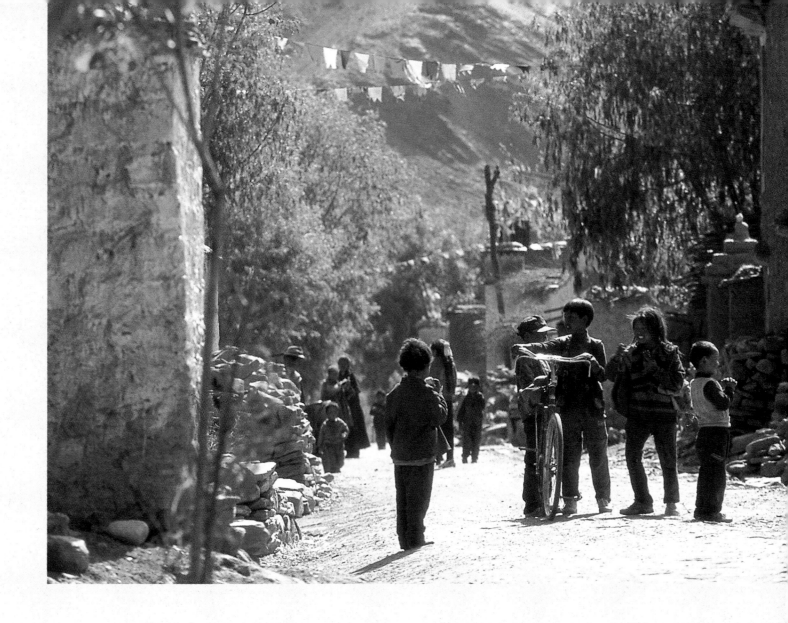

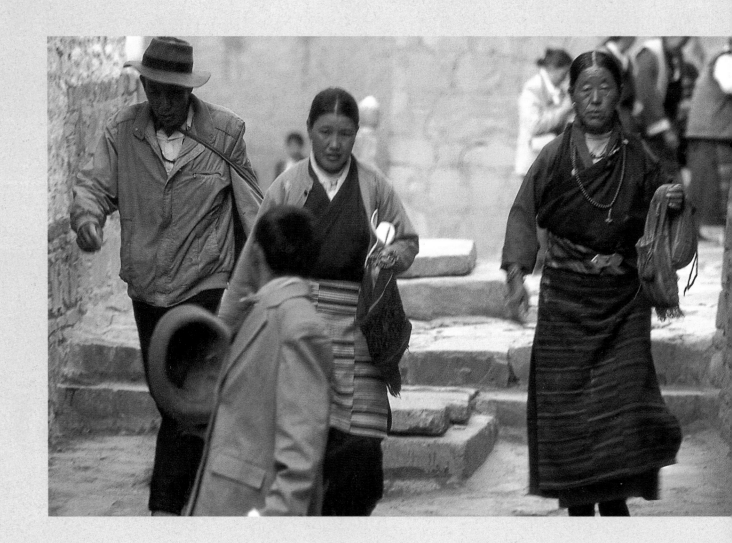

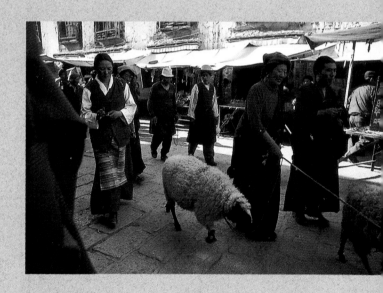

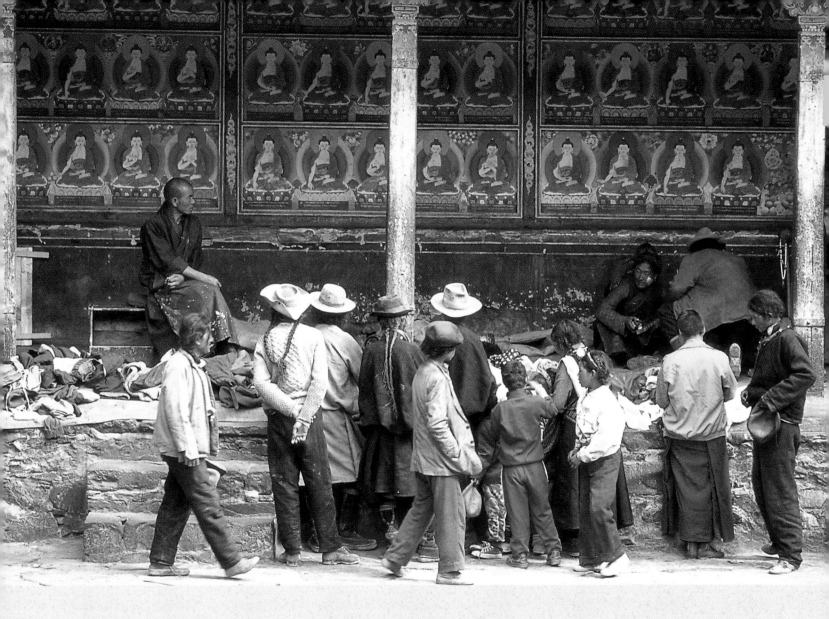

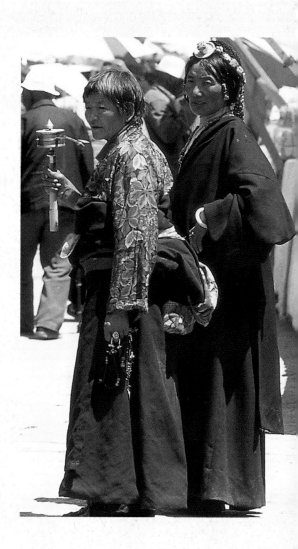

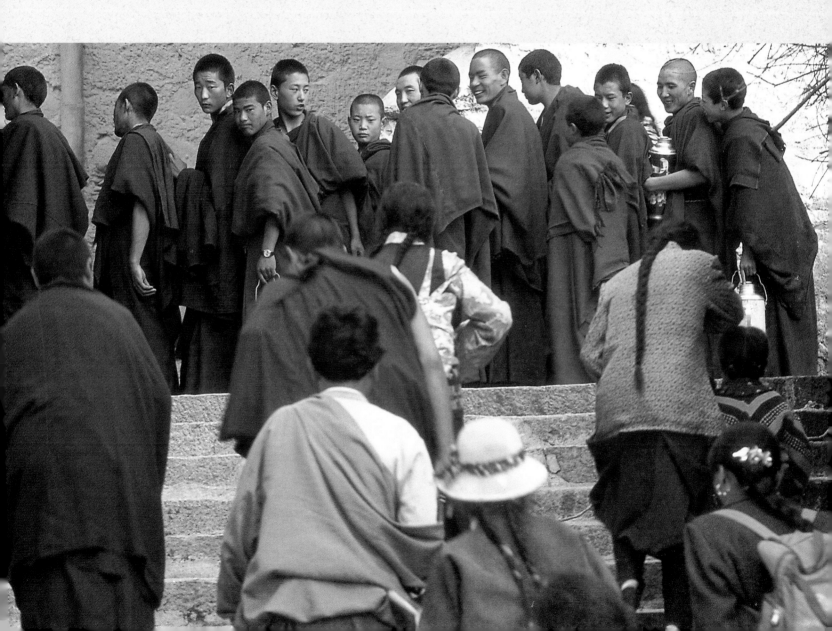

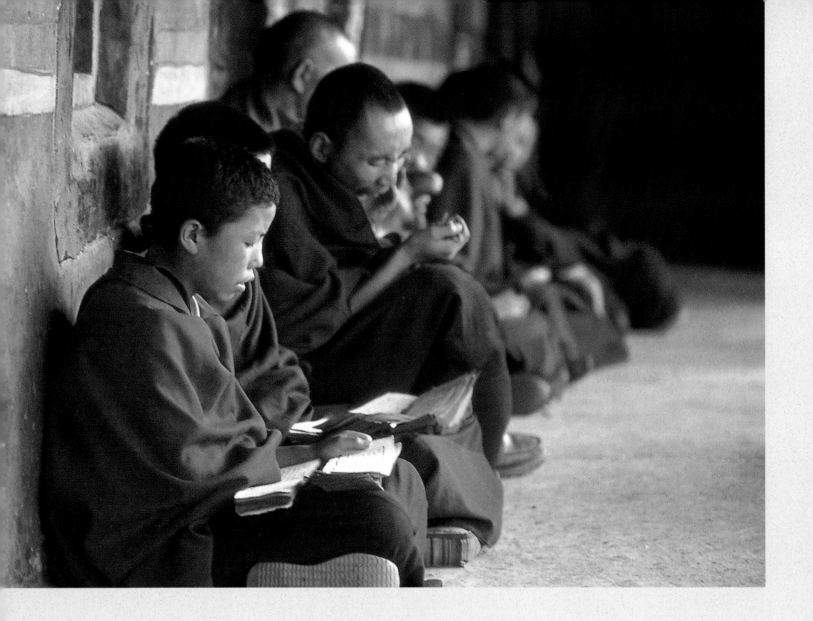

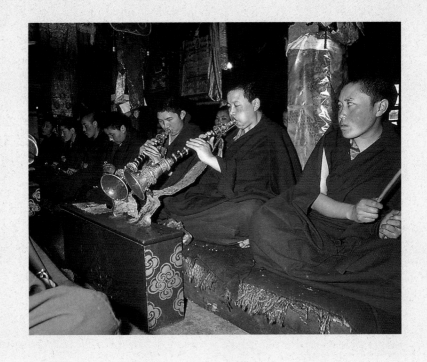

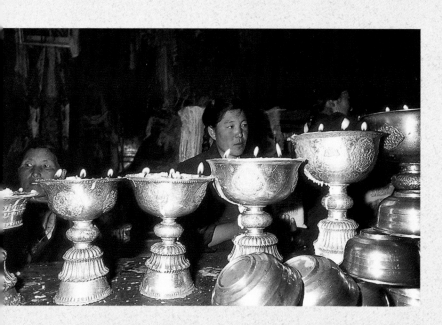

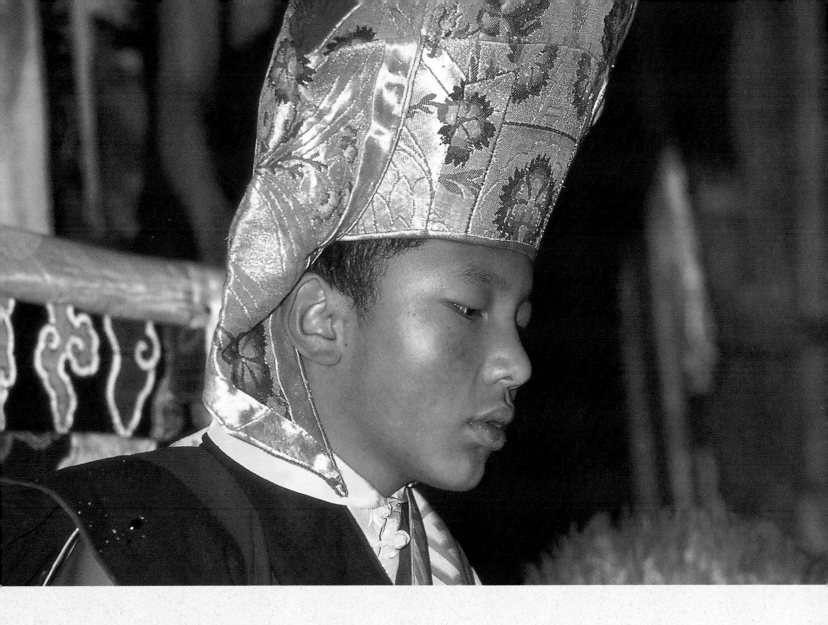

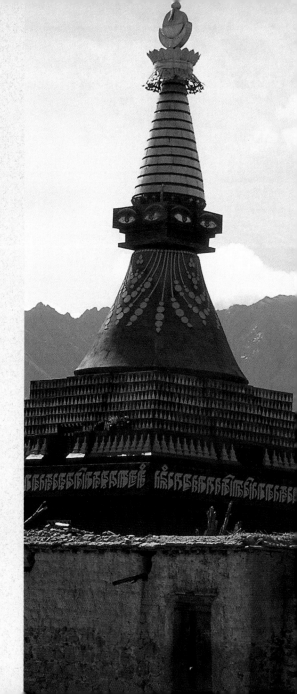

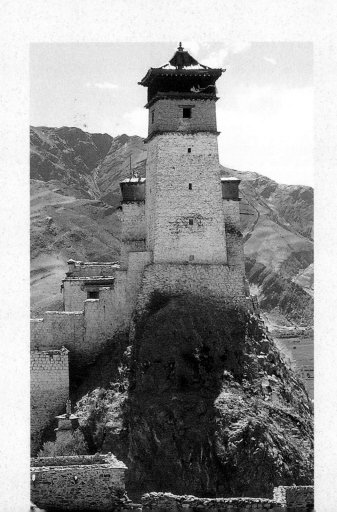

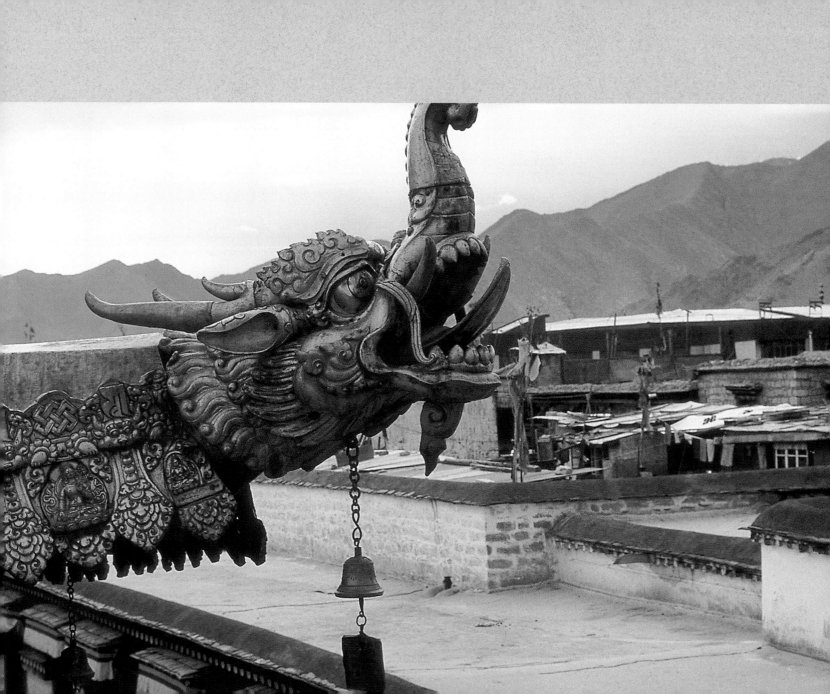

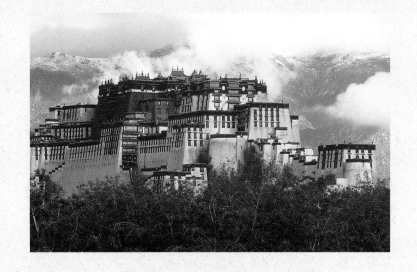

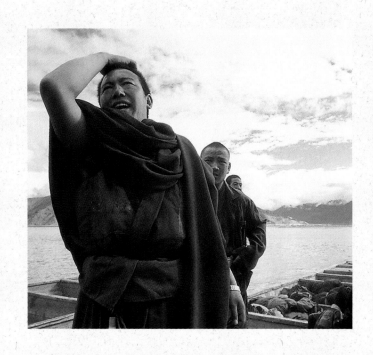

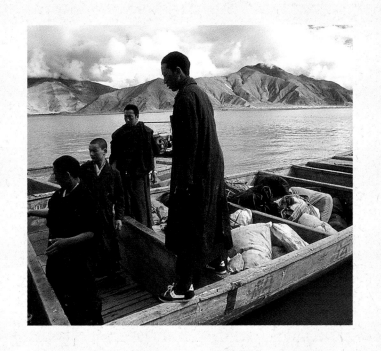

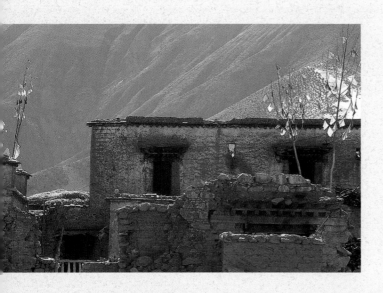

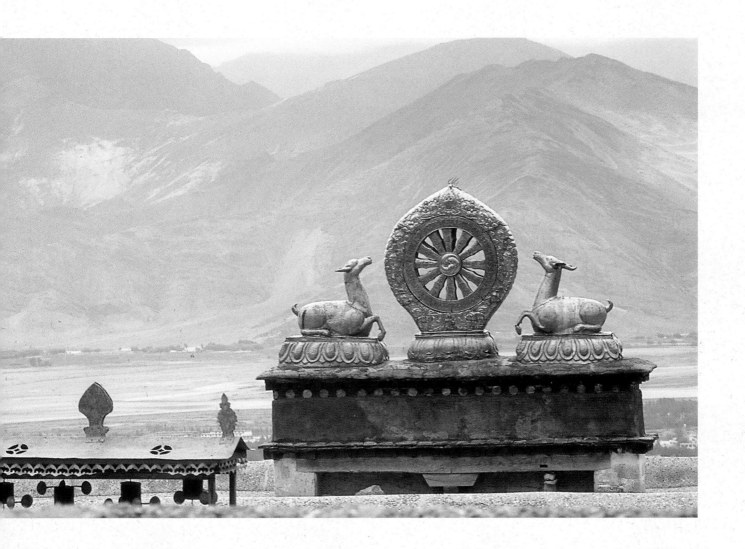

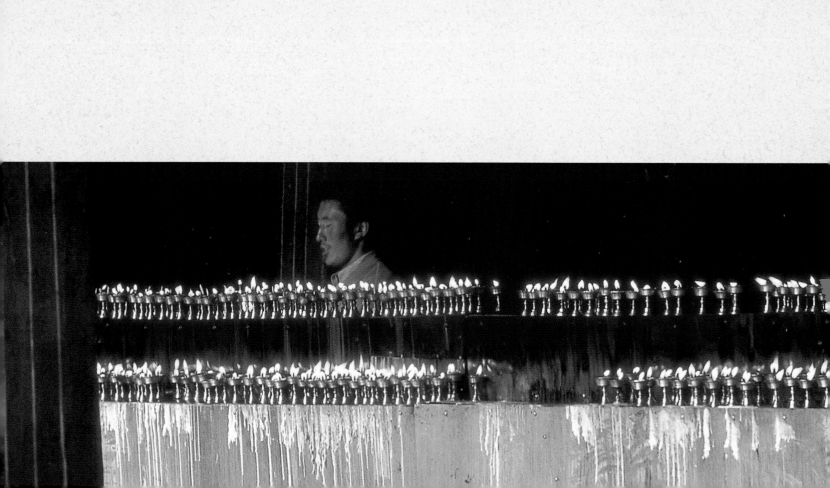

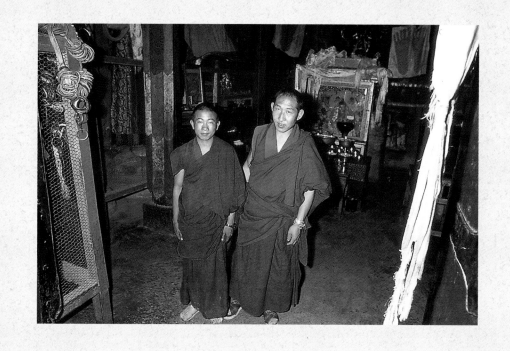

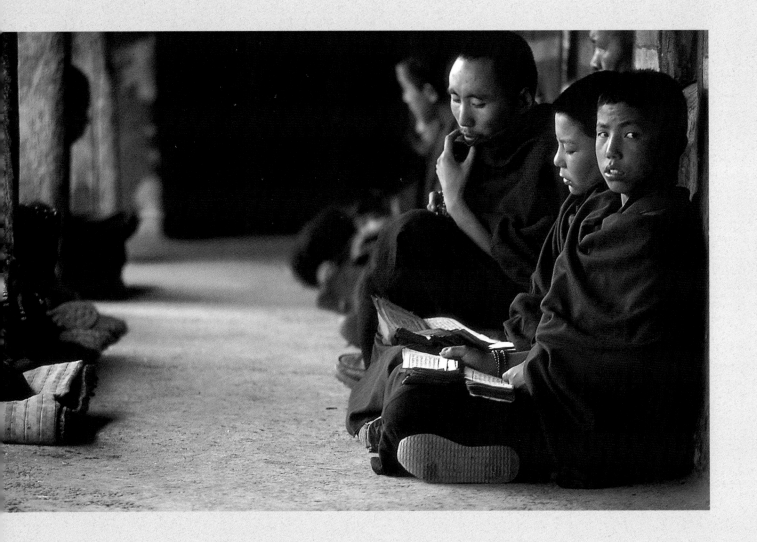

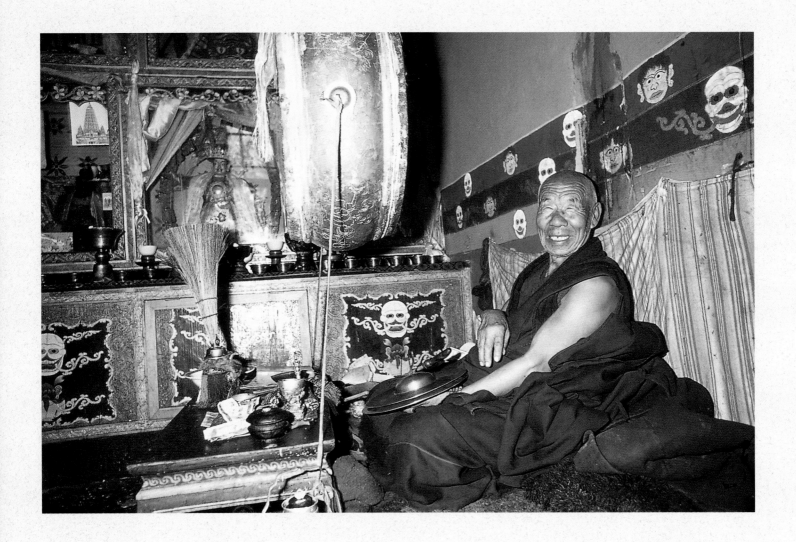

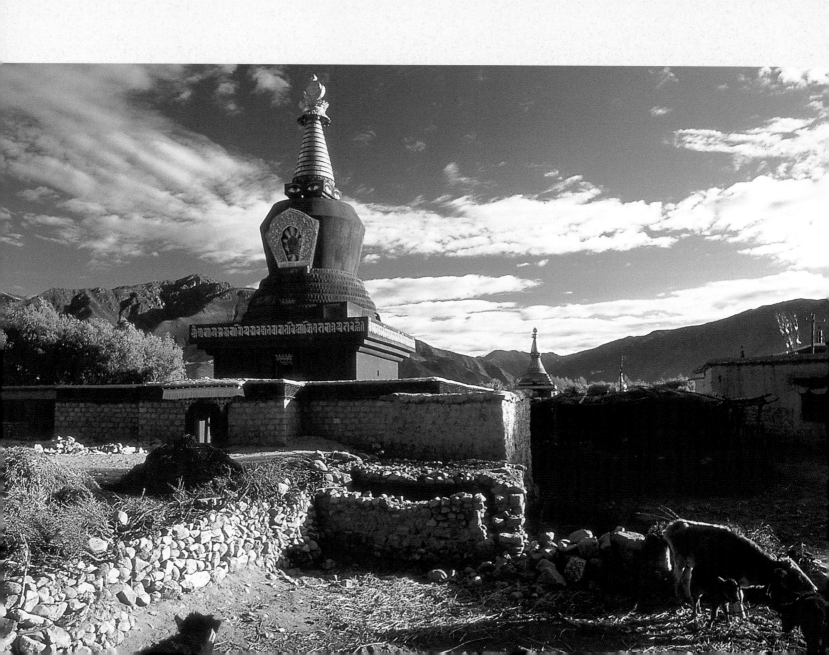

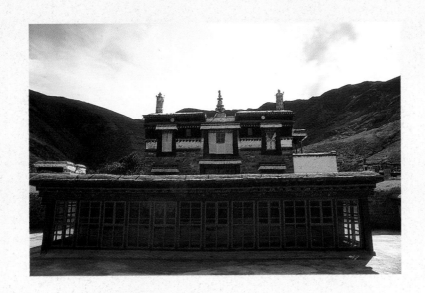

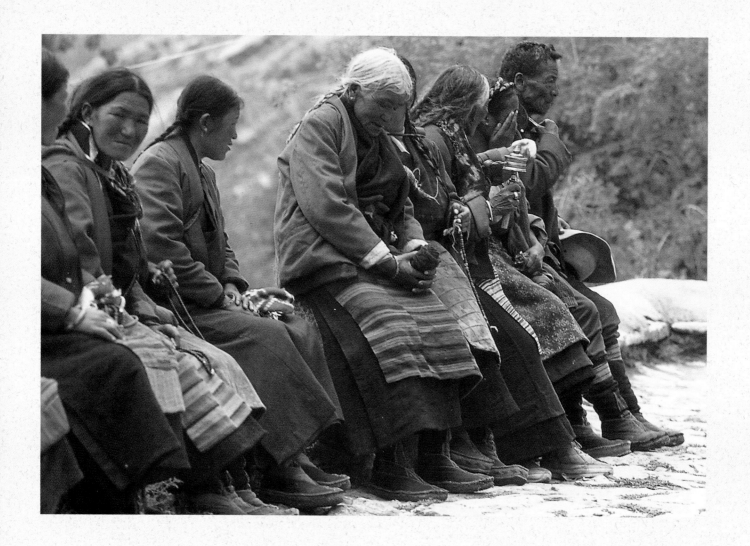

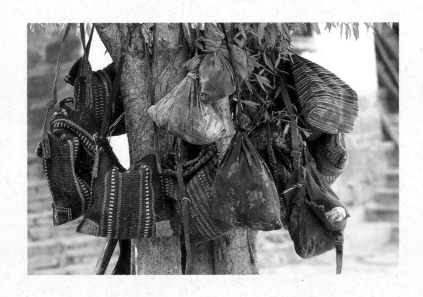

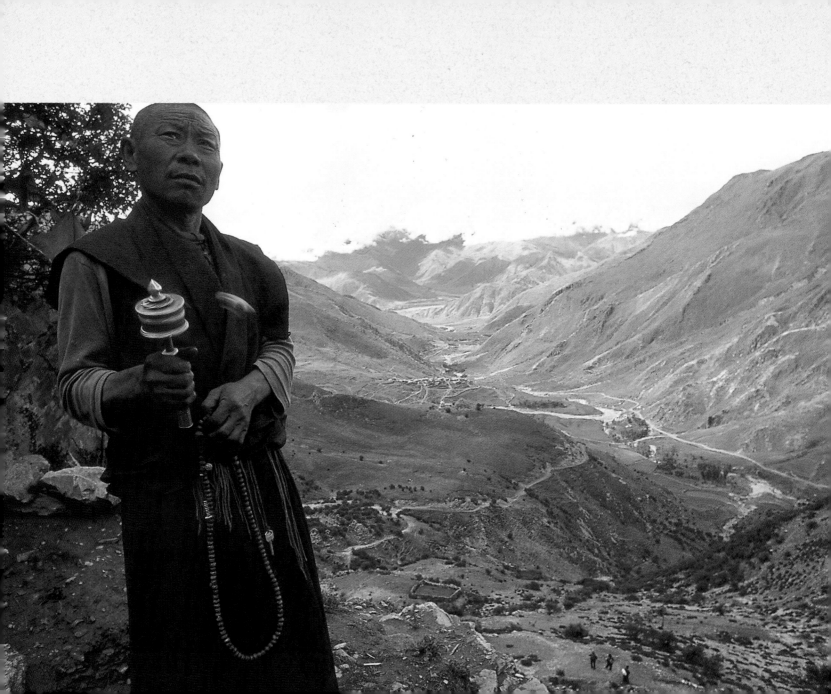

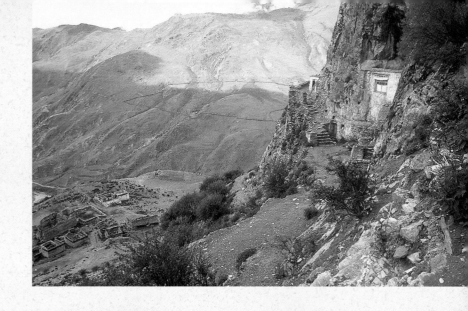

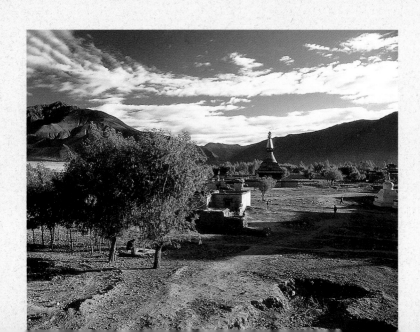

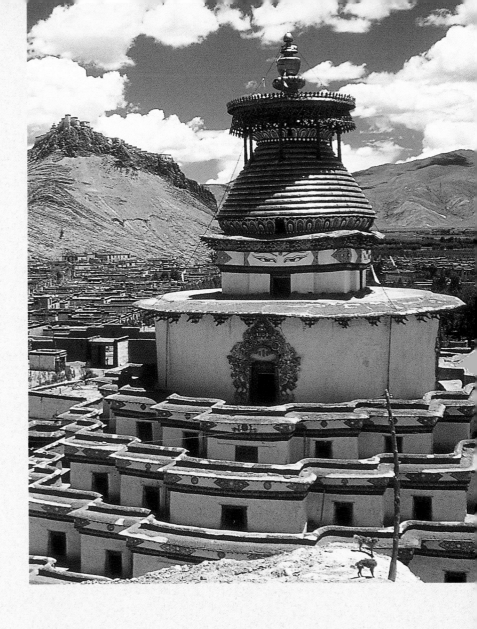

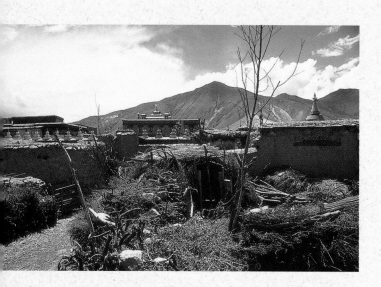

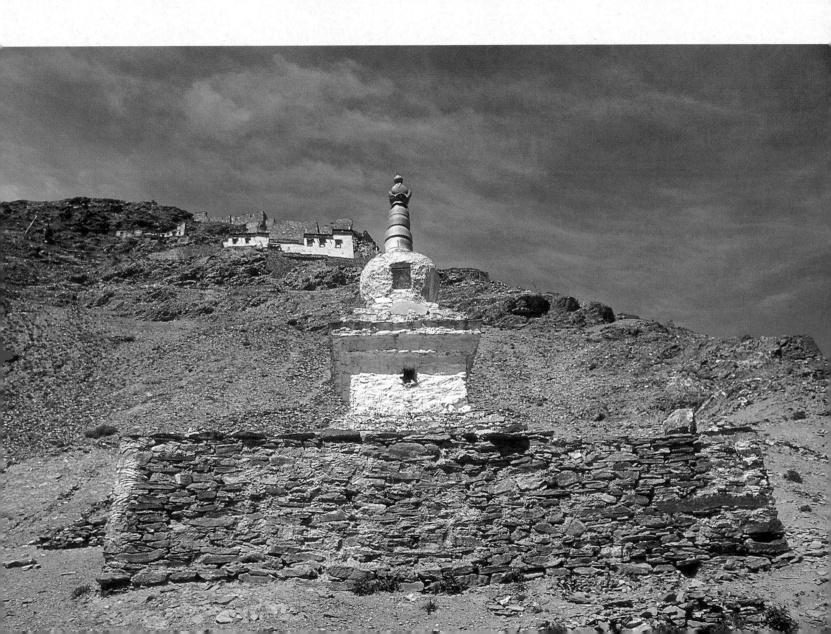

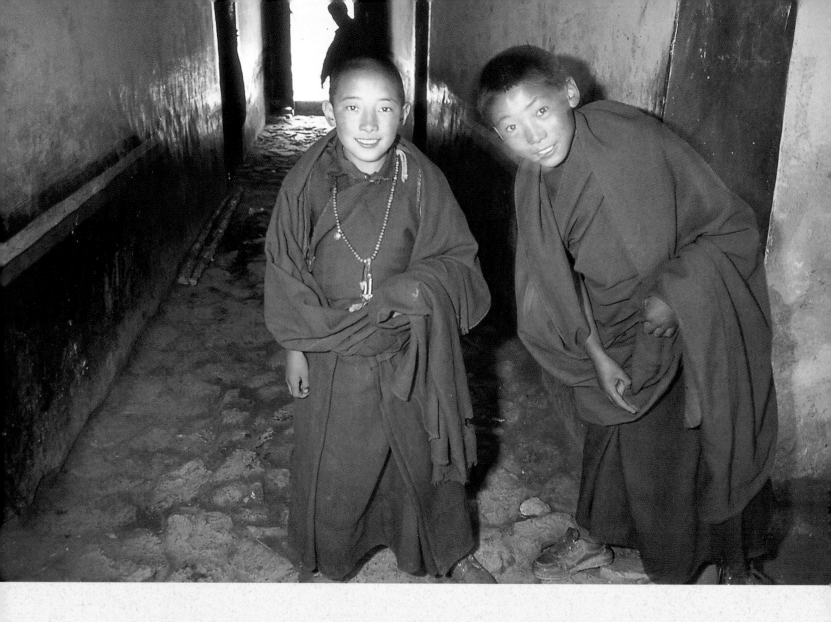

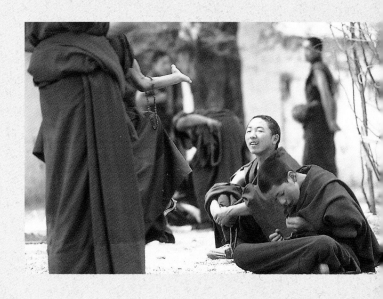

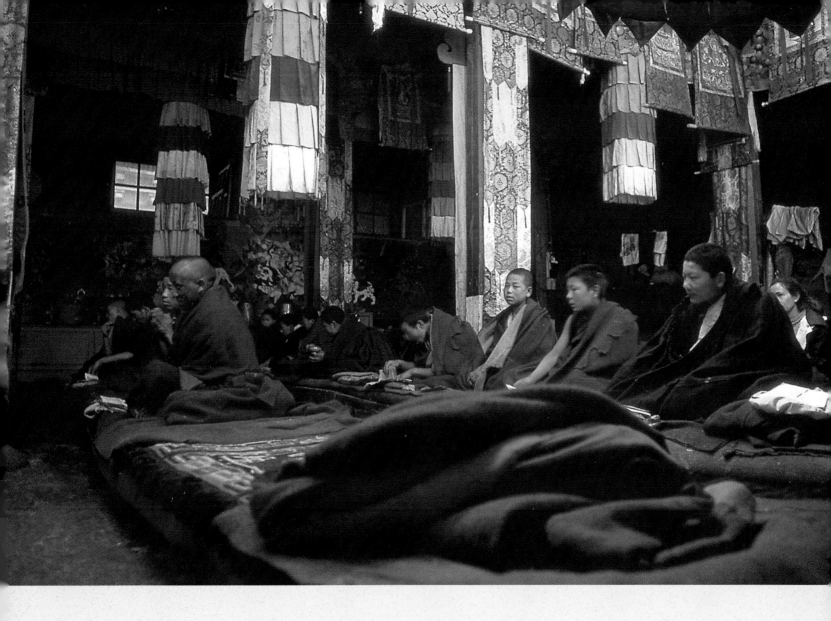

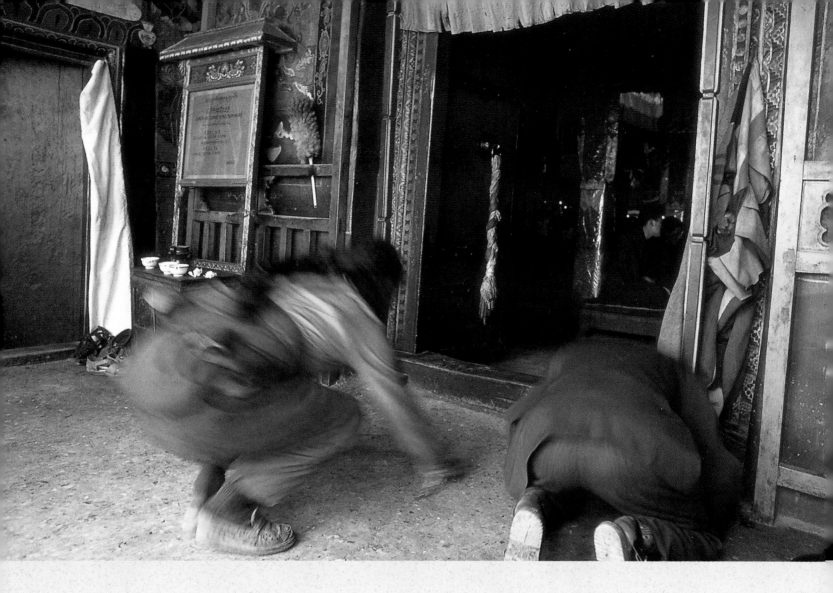

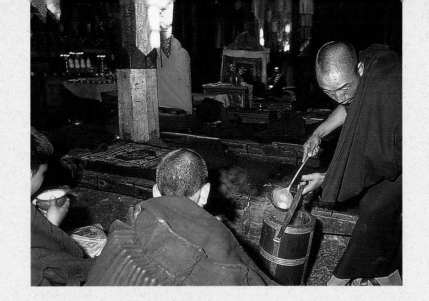

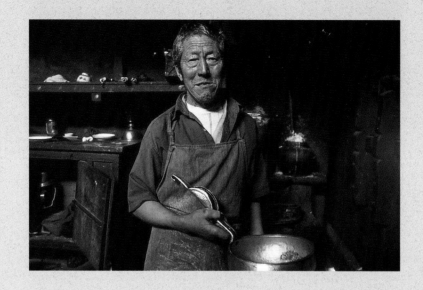

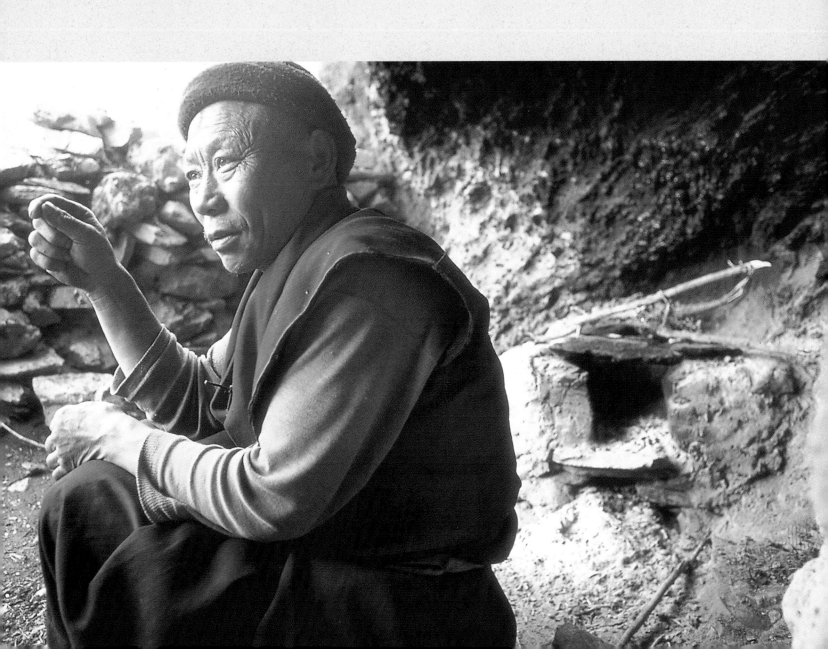

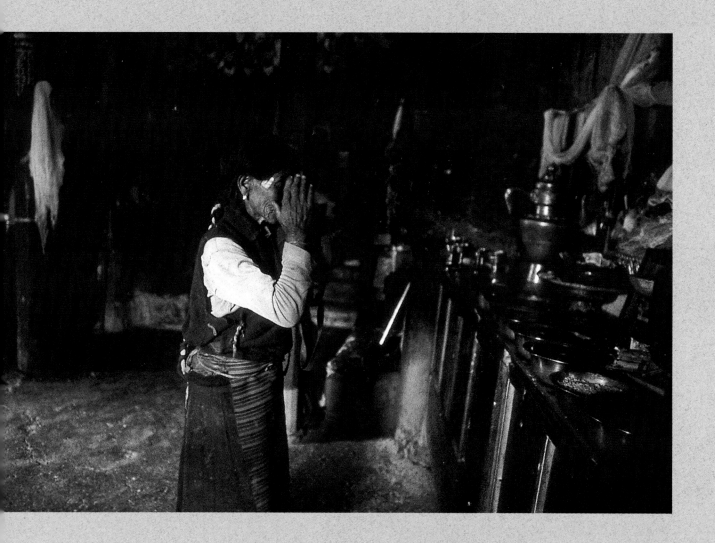

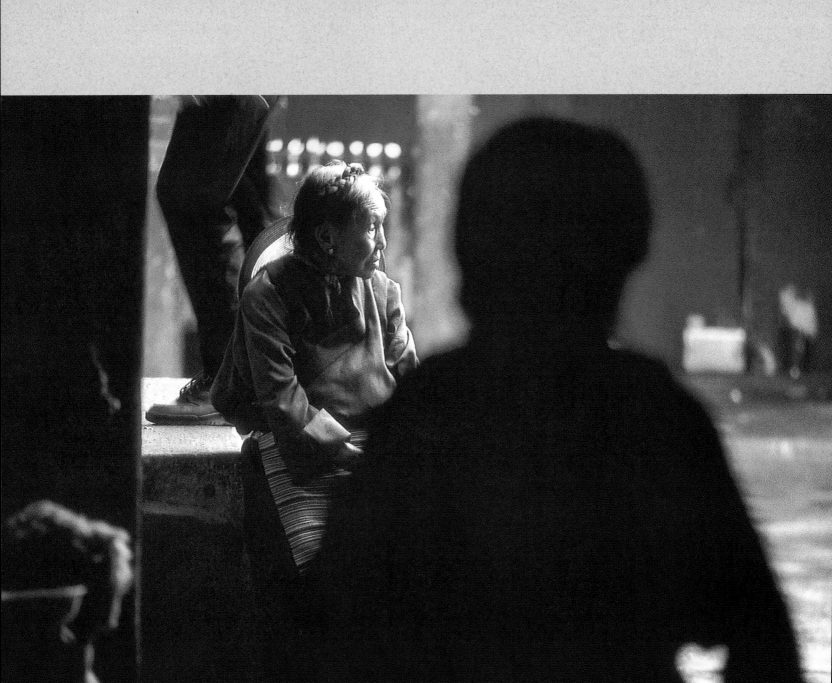

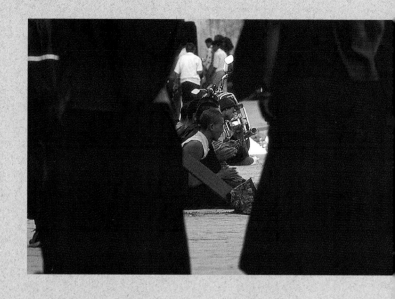

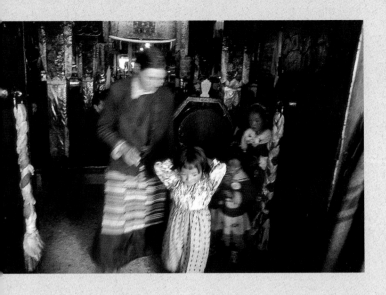

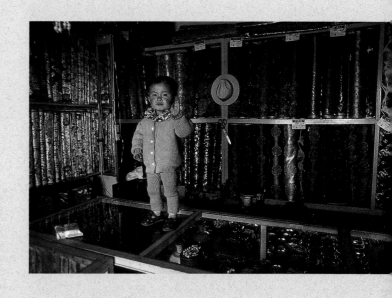

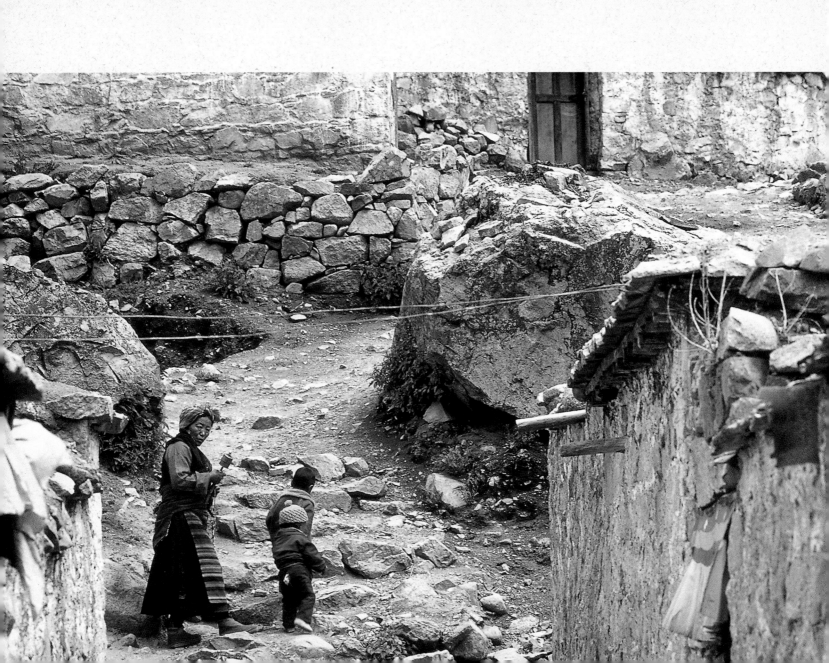

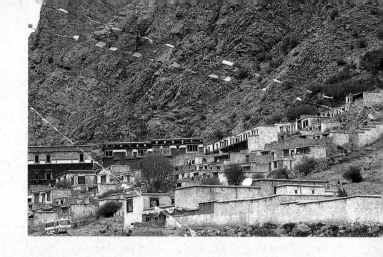

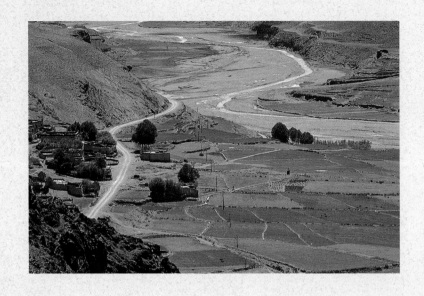

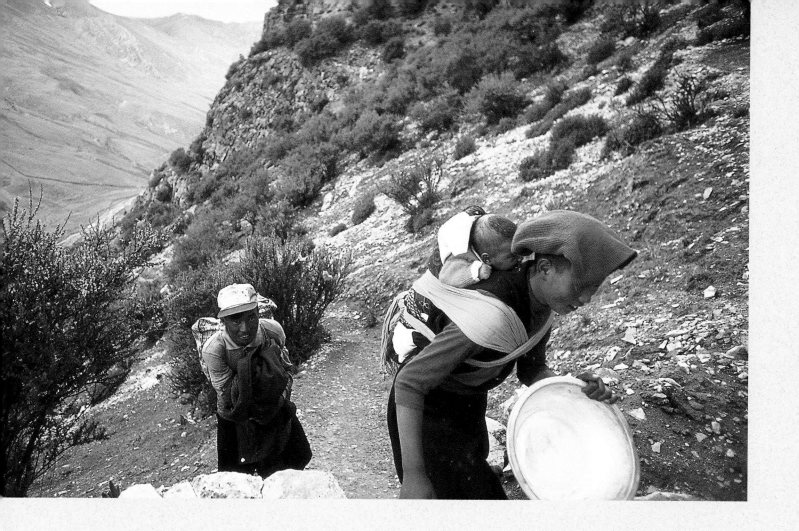

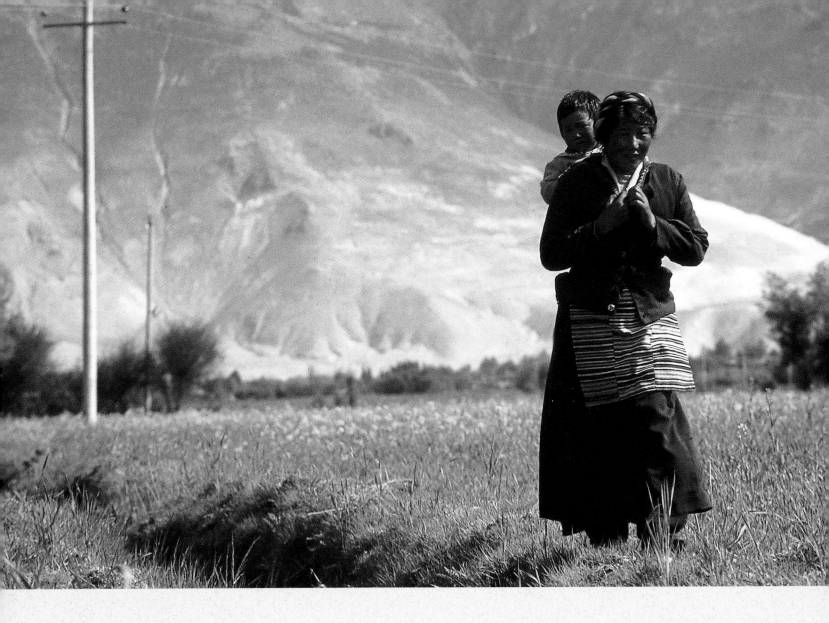

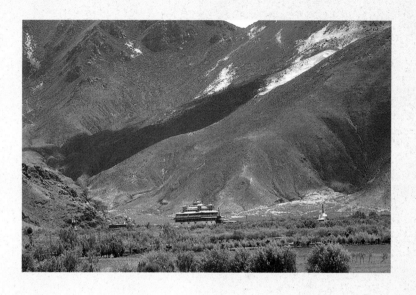

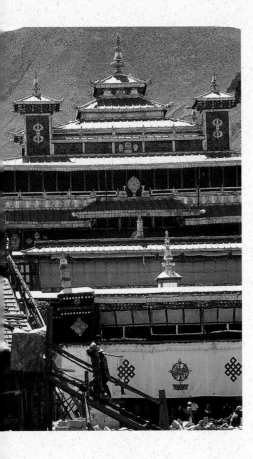

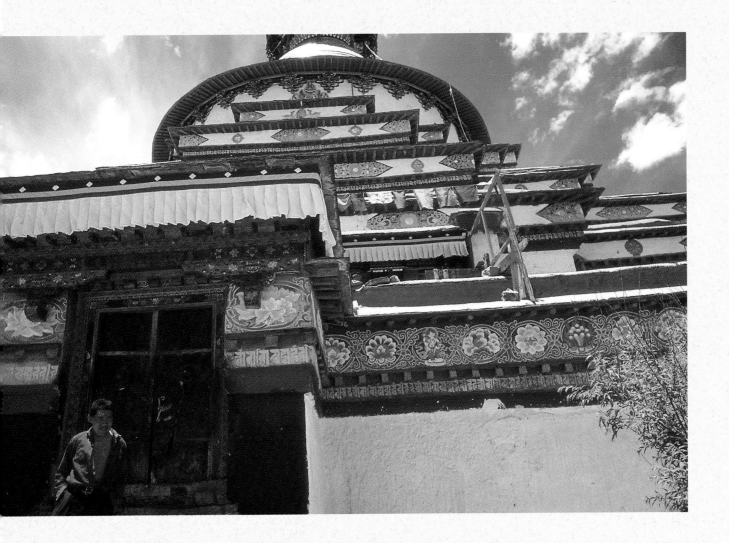

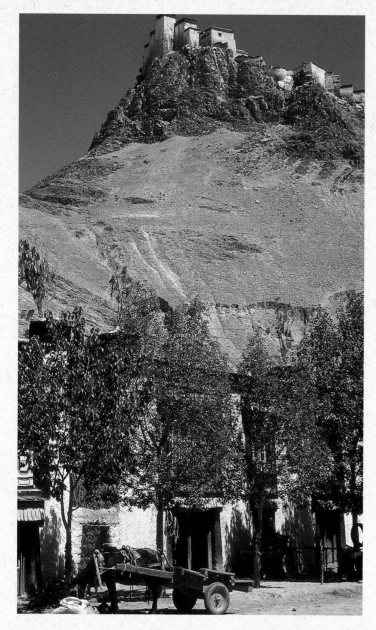

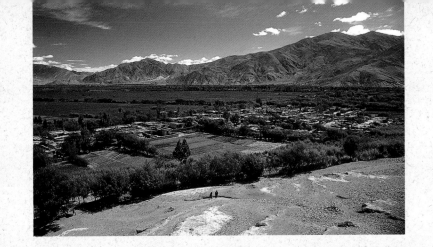

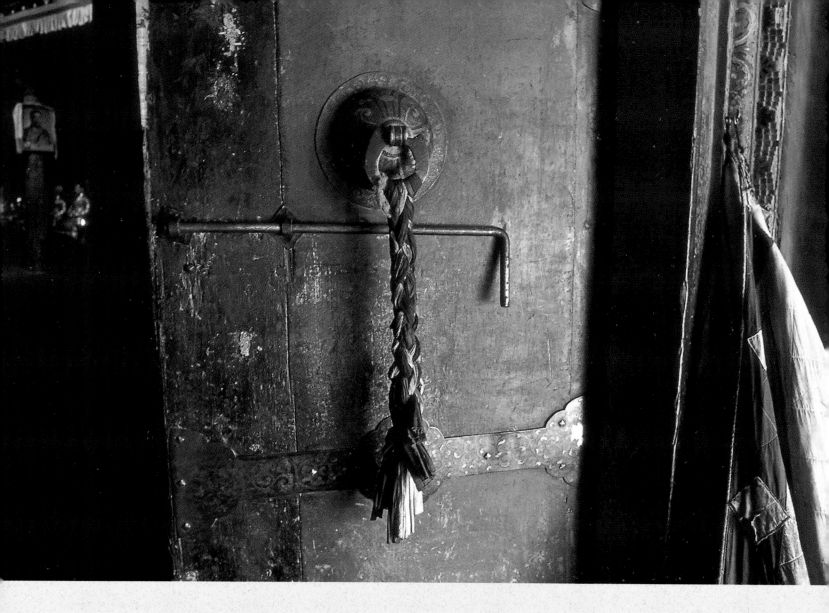

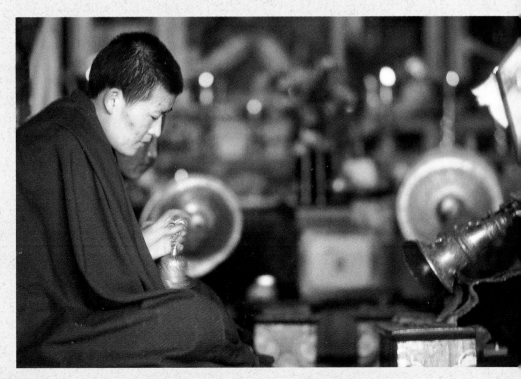

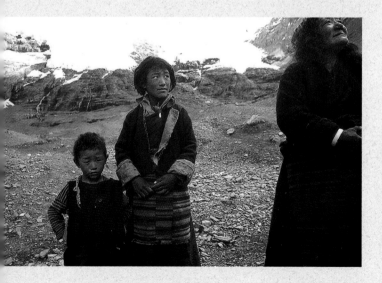

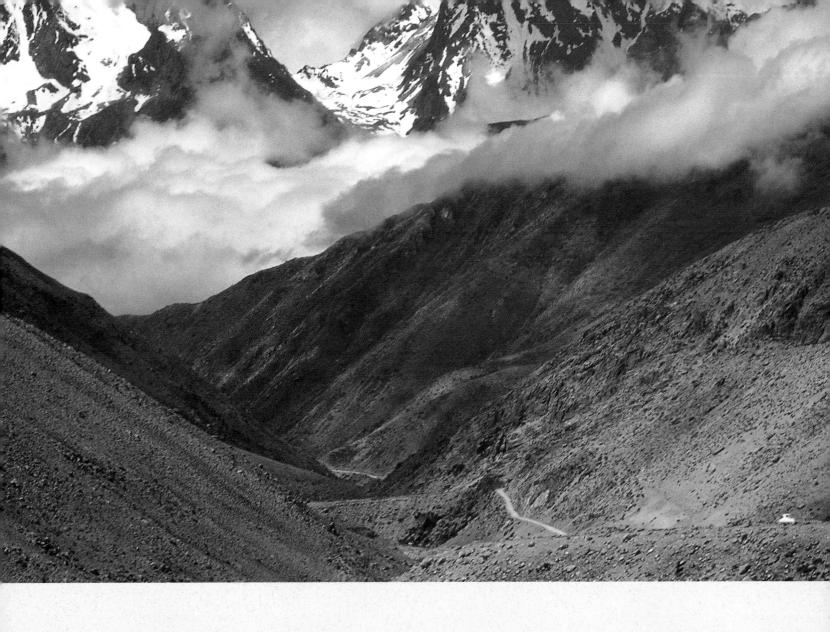

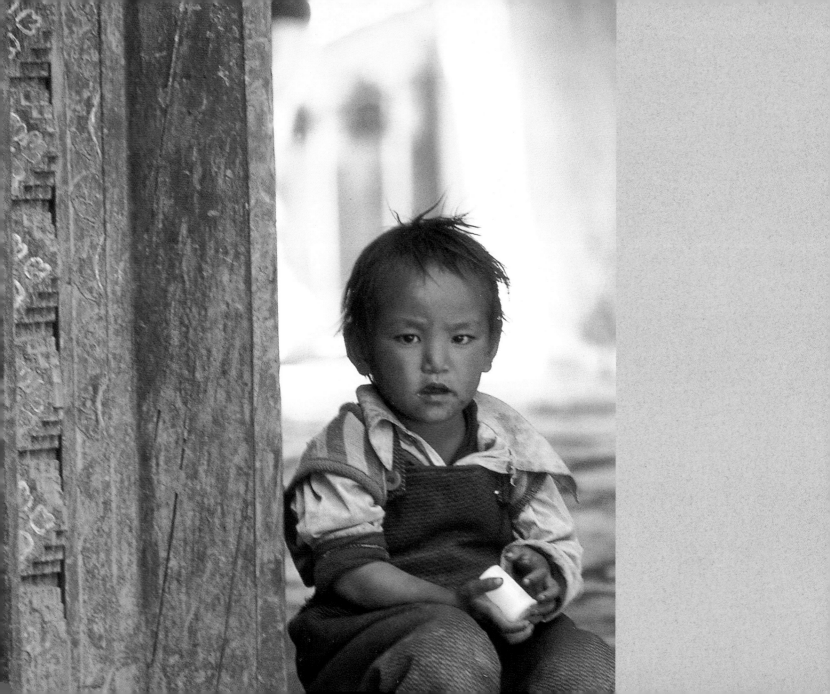

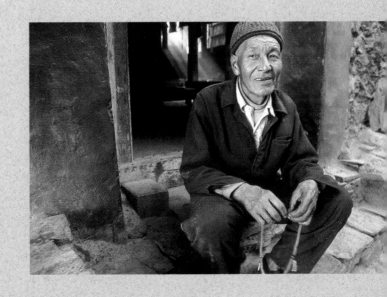

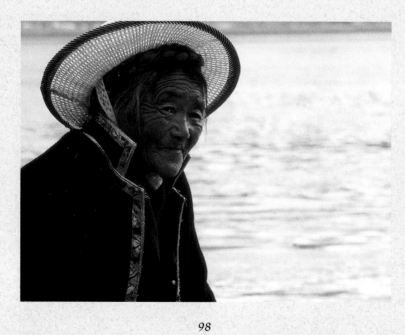

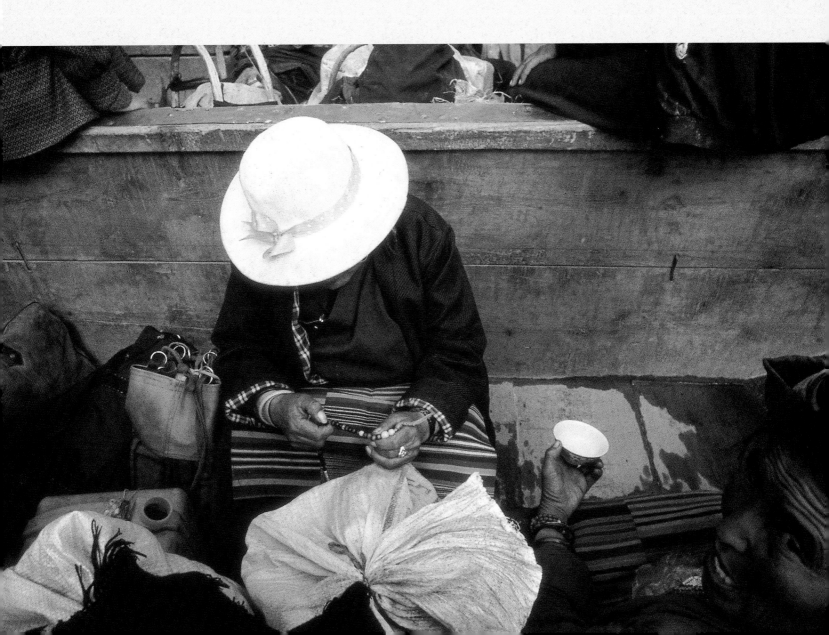

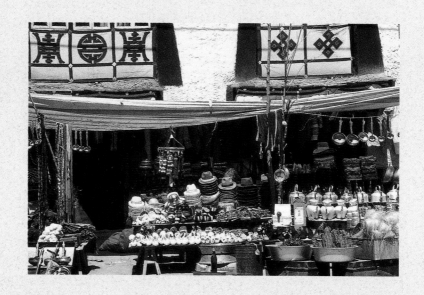

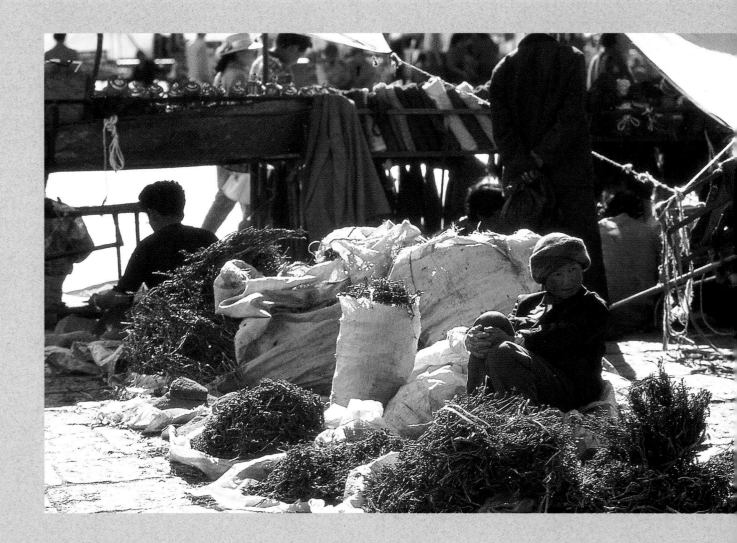

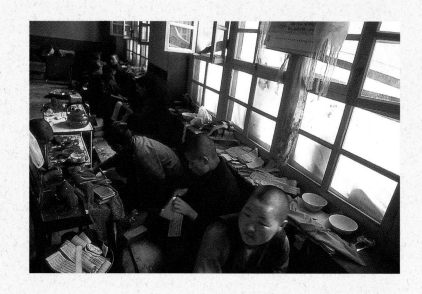

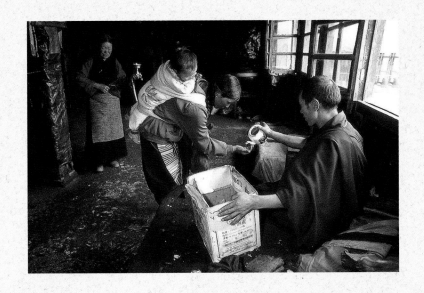

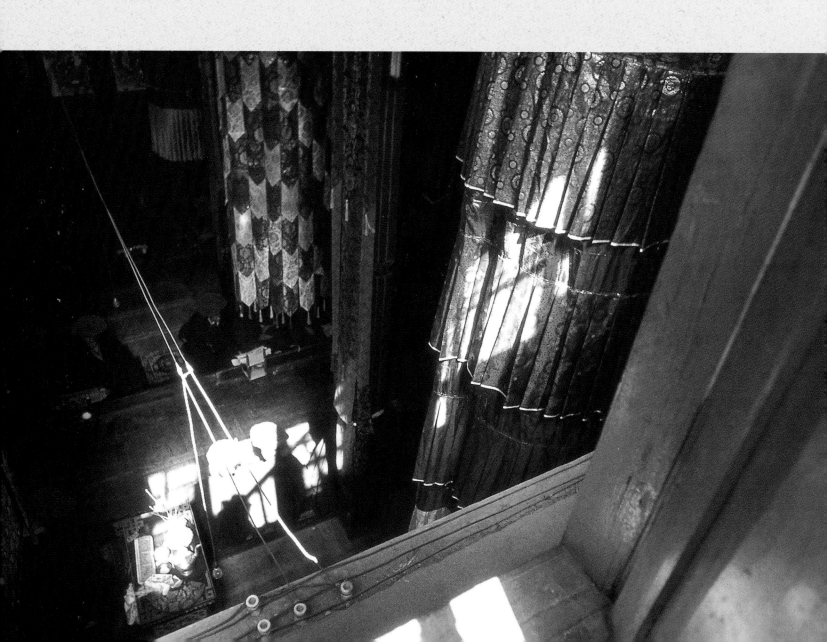

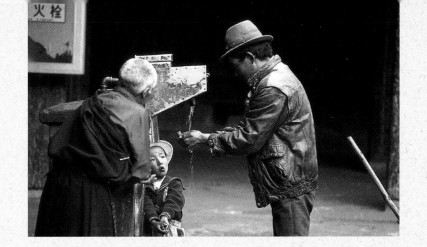

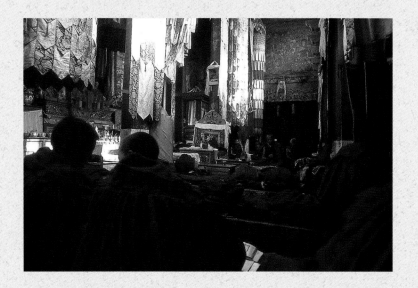

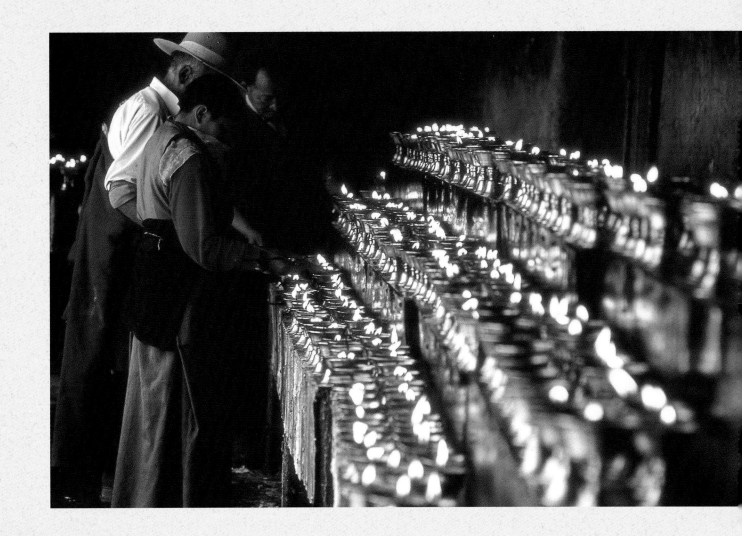

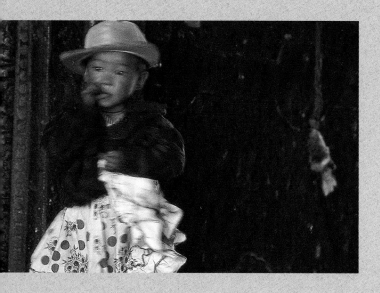

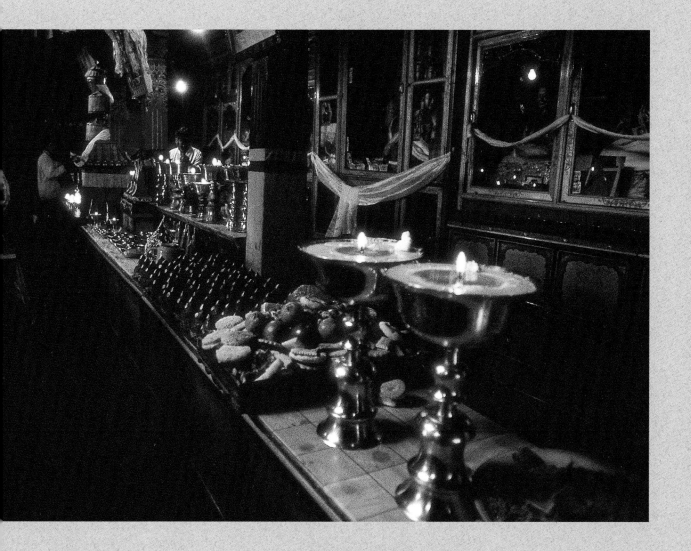

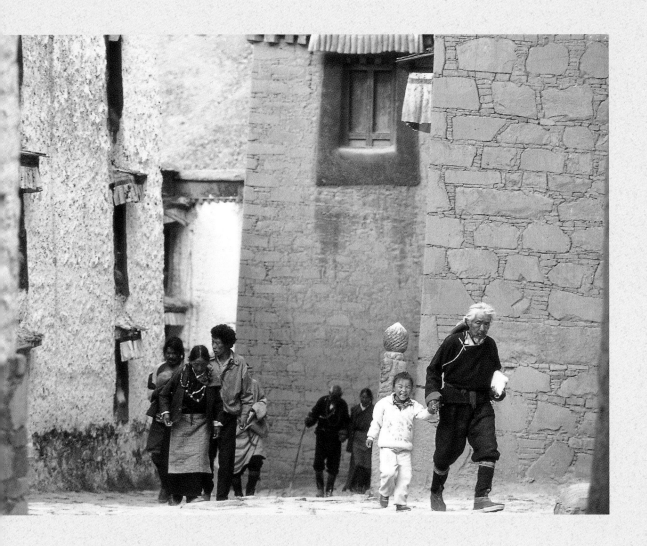

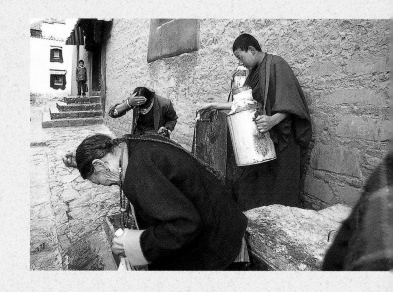

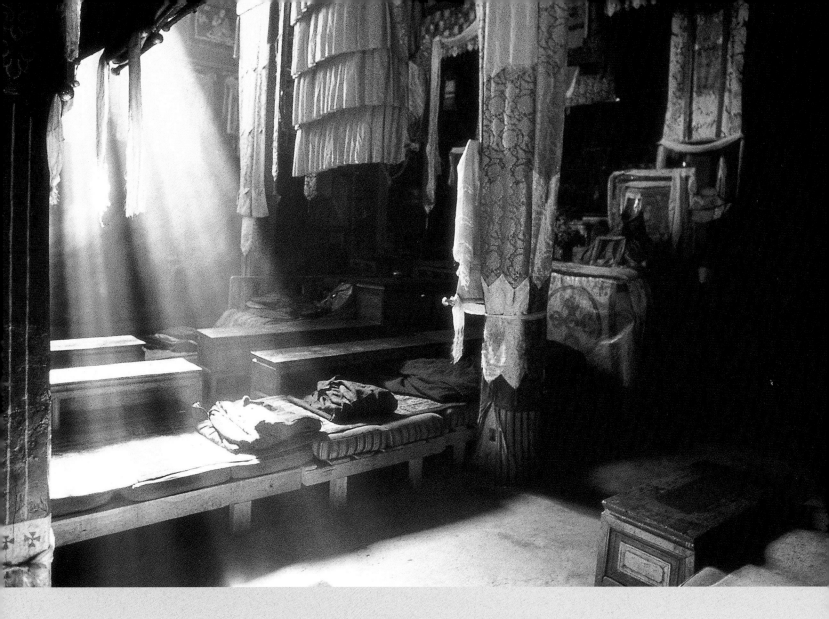

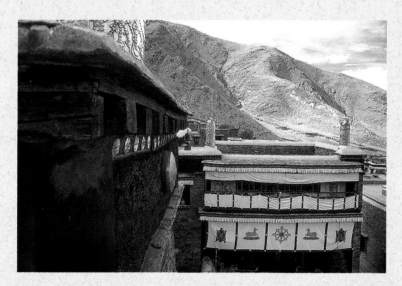

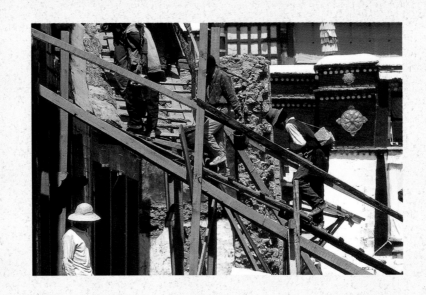

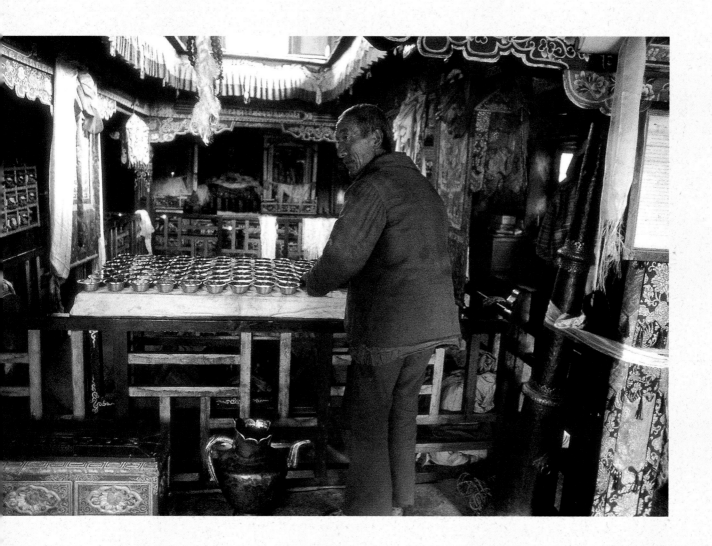

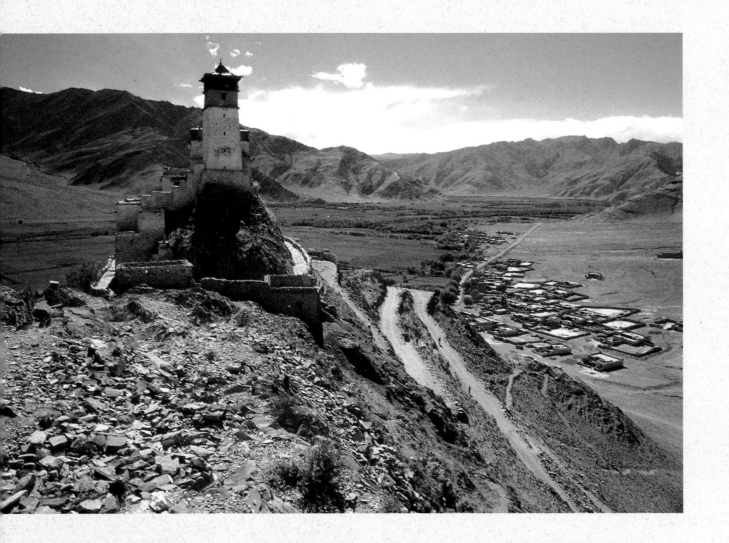

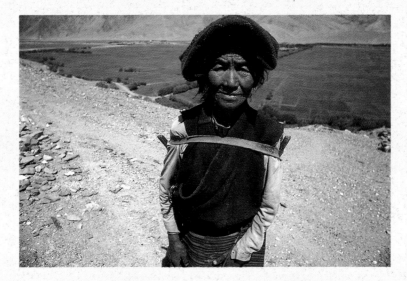

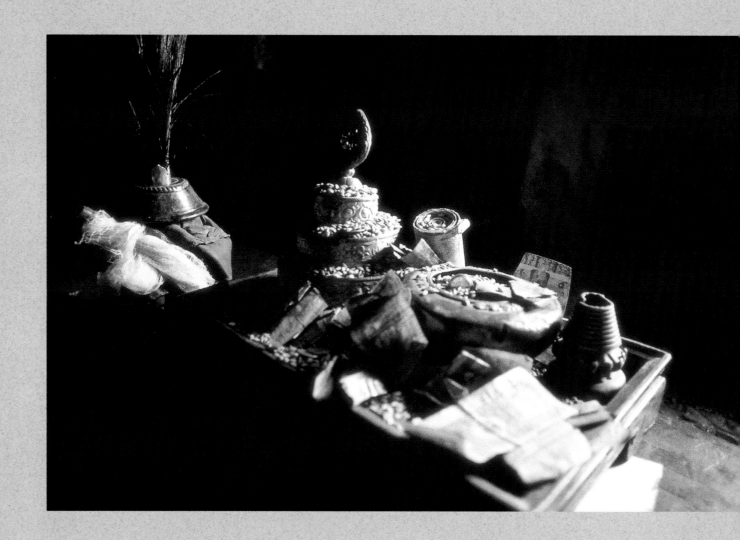

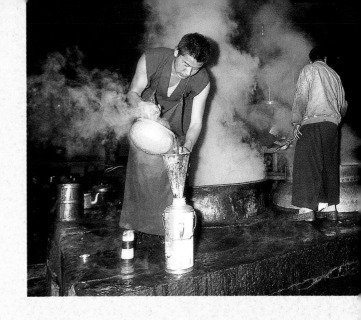

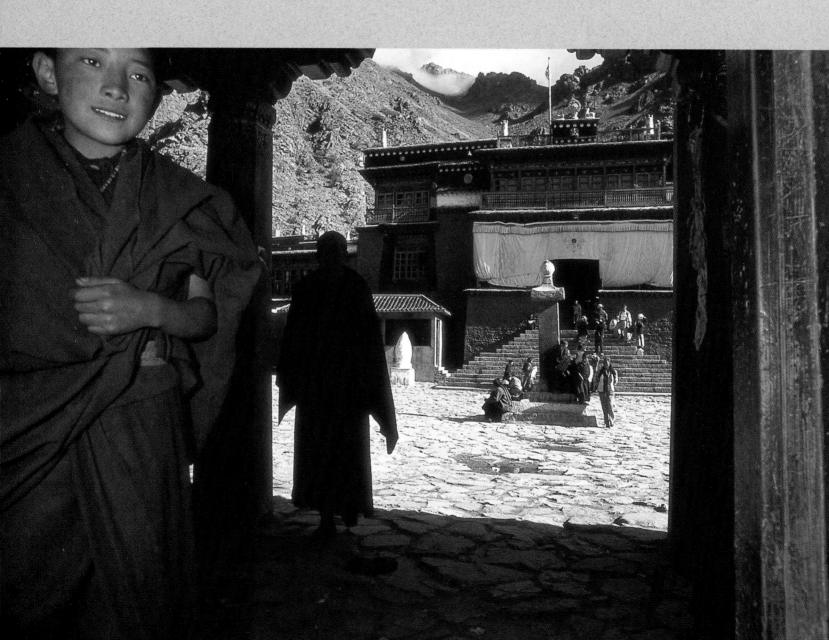

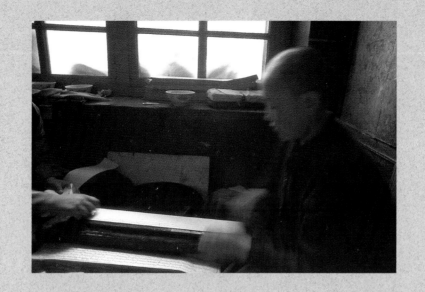

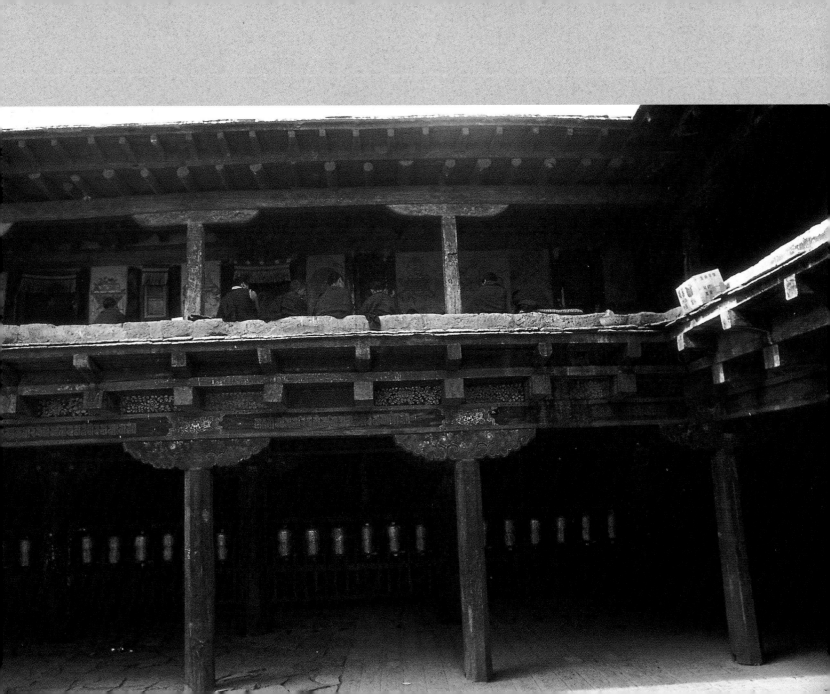

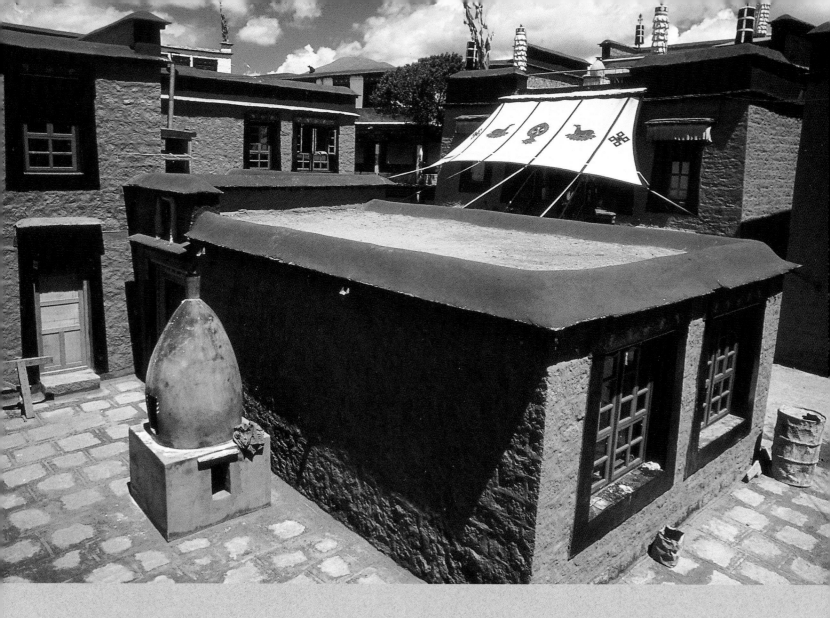

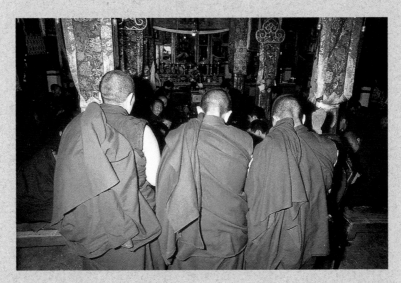

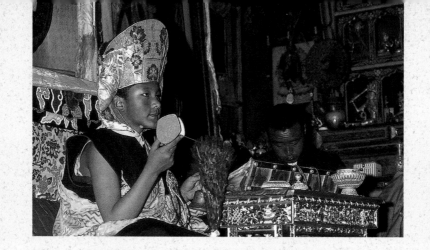

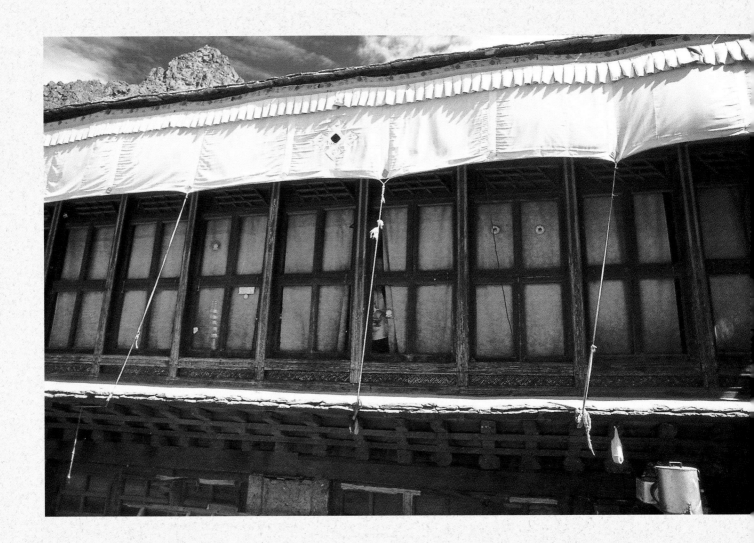

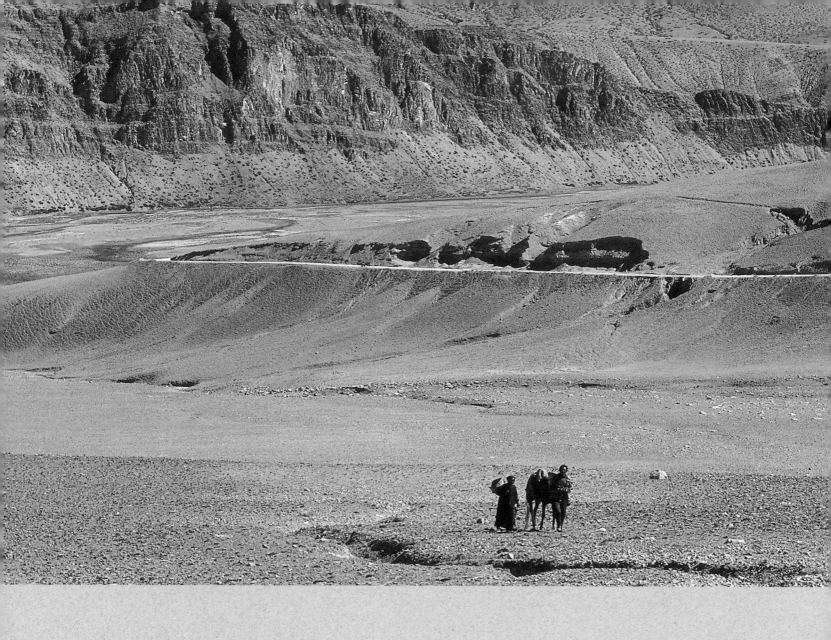

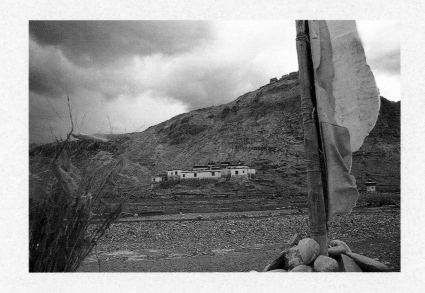

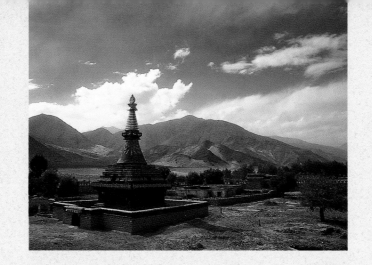

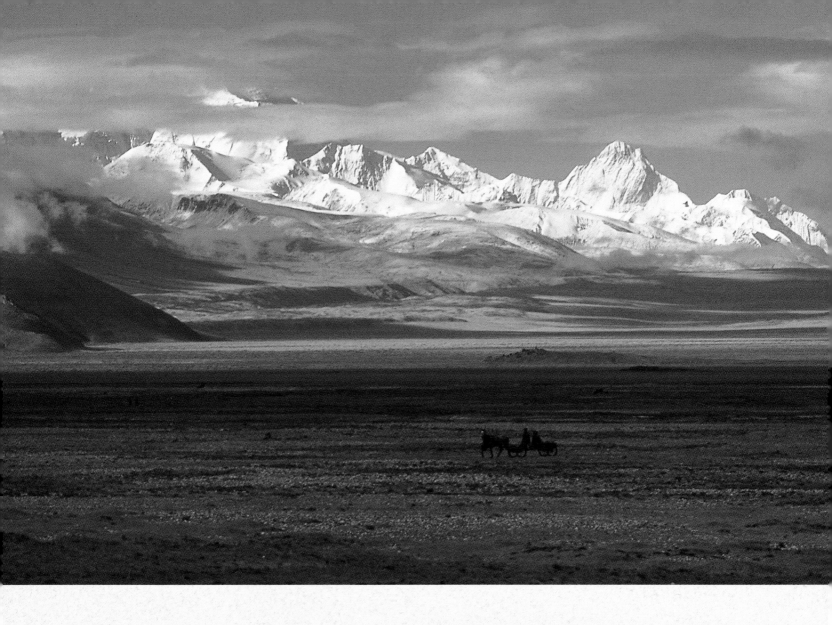

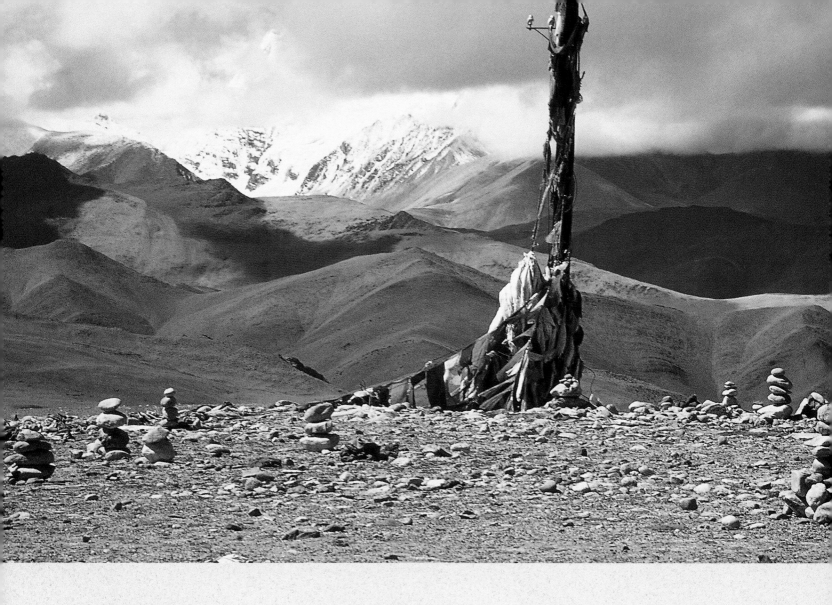

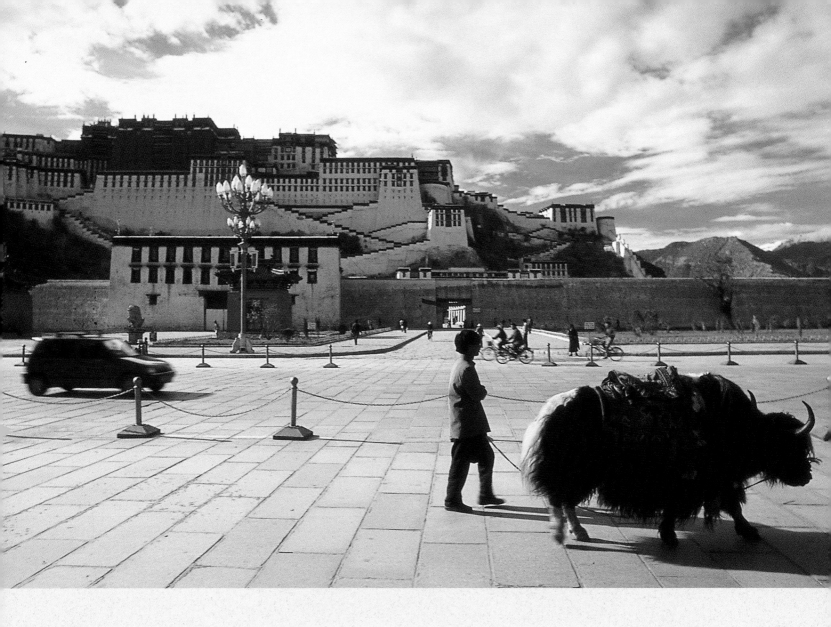

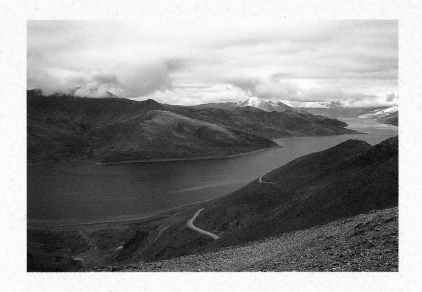

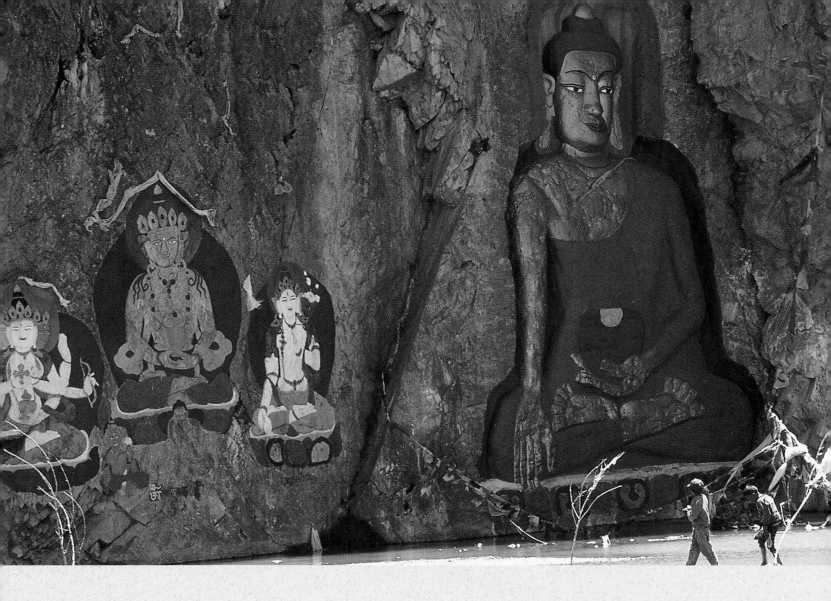

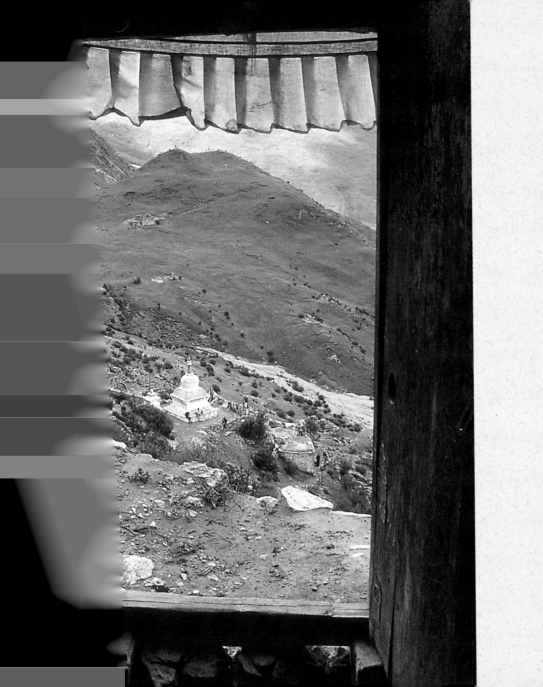

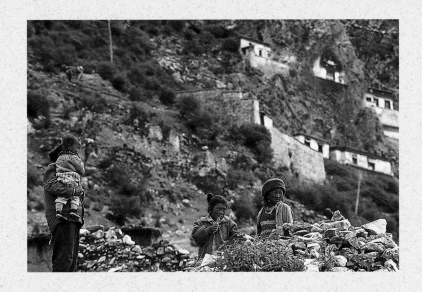

Captions

Cover: Young boy stands by butter lamps he has just lit in a courtyard of the Jokhang Temple, Lhasa.

2. Prayer flags on the top level of the Potala Palace, Lhasa.

3. Iowo Buddha, Jokhang Temple, Lhasa.

4. His Holiness the 17th Karmapa, 13 years old, in Tsurpu Monastery.

5. Entrance to a house, Tsedang.

6. A lama carries a book of Buddhist scriptures at Tashi Lhunpo Monastery.

7. A man carries his goods in front of the entrance to Tsurpu Monastery.

8. Monk at the entrance to his dwelling on the mountain at Drek Yerpa.

9. Village in Tsedang.

10–11. Monks go through the debating practice in a shady courtyard at Sera Monastery.

12. Prayer flags fly over Rechung Pak Monastery, Tsedang.

13. Girl outside Milarepa's cave.

14–15. Monks at Sera Monastery.

16. Tashilunpa Monastery, Shigatse.

17. Villagers ring the bell before entering Tashilunpa Monastery, Shigatse.

18. Young girl outside Mindroling Monastery.

19. Woman at the Jokhang, Lhasa.

20. A well decorated with prayer flags in Drek Yerpa.

21. Bridge decorated with prayer flags in Drek Yerpa.

22. Brightly painted monks' rooms at Samye Monastery.

23. Women and a young boy gather in the inner courtyard of the Jokhang Temple, the "central cathedral of Buddhism." It is Tibet's most important pilgrimage site and the center for Buddhism.

24. Burial site at Tsurphu Monastery.

25. Bracken dries near a stupa near Milarepa's cave.

26. The Wheel of Dharma flanked by two deer on the roof of the Jokhang Temple overlook the Potala Palace, the official winter residence of all the Dalai Lamas.

27. Prayer flags at Ultringway.

28. Part of Mindroling Monastery.

29. Prayer flags and a lammergeier (vulture, far left) at Ultringway.

30. Barkhor Bazaar, the market that surrounds the Jokhang in Lhasa.

31. Worshippers pray before entering the Jokhang Temple in Lhasa.

32. Children at Drolma Lhakang Monastery.

33. Street in Tsedang.

34. Tashilumpo Monastery near Shigatse was founded in 1447.

35. Worshippers walk around and around the Jokhang Temple, Lhasa.

36. Local people sell secondhand clothing in front of a painted wall depicting hundreds of boddhisattvas inside Tashilumpo Monastery.

37. Two women, resplendent in silk braids and turquoise, with prayer wheels in the Barkhor, Lhasa.

38. A kiosk outside Mindroling Monastery.

39. Drepung Monastery, Lhasa.

40. Monks at their daily studies at Samye Monastery which was nearly destroyed by the Chinese during the Cultural Revolution.

41. Female monks play the horns in Tsang Kung Monastery, Lhasa.

42. Worshippers light butter lamps inside Samye Monastery.

43. His Holiness the 17th Karmapa during an audience at Tsurphu Monastery. (He was 13 years old at the time and has since fled to India.)

44. A stupa at Samye Monastery.

45. Yambulakhalang Palace, Tsedang.

46. Gilded dragon on the rooftop of the Jokhang.

47. Potala Palace, Lhasa.

48–49. Monks crossing the Brahmaputra River.

50. The village surrounding Samye Monastery, which was built between 763 and 775.

51. The Wheel of Dharma flanked by two deer on the roof of the Jokhang Temple.

52. Candles are lit inside the Jokhang in Lhasa.

53. Drolma Lhakang Monastery near Lhasa.

54. Young monks study Buddhist scriptures at Samye Monastery.

55. Tashi Lhunpo Monastery.

56. In a protector chapel in the Drolma Lhakang Monastery, approximately 20 kilometers from Lhasa, a monk prays around the clock.

57. Samye Monastery.

58. A stupa near Samye Monastery.

59. Mindroling Monastery.

60. Local people wait outside Drepung Monastery, Lhasa.

61. Workers' bags hang on a tree at Mindroling Monastery.

62. A monk near Tashi Lhunpo Monastery. With each spin of his prayer wheel, the scrolls contained in the cylinders release several prayers to the heavens.

63. Houses and meditation caves at Drek Yerpa.

64. Stupas and houses surround Samye Monastery.

65. Palkhur Monastery, Gyantse.

66. Samye Monastery.

67. A stupa outside Rechung Pak Monastery, Tsedang.

68. Young monks aged nine and ten at Tsurphu Monastery.

69. Monks at their studies at Samye Monastery.

70. A monk fills the butter lamps in front of the Jowo Buddha in the Jokhang Temple, Lhasa.

71. Monks worship at Samye Monastery.

72. Visitors bow and kneel before entering the Tsang Kung Monastery, Lhasa.

73. Yak butter tea is distributed in Samye Monastery.

74. In the kitchen at Mindroling Monastery, a monk prepares meals in a brass cooking pot.

75. A monk sits at the entrance to one of the Drek Yerpa caves on the side of a mountain near Tashi Lhunpo Monastery.

76. In a monastery in Tsedang, an elderly woman makes her daily prayers. Despite the Chinese government's desire to eradicate Buddhism from the country, Tibetans visit the monasteries daily.

77. Tashi Lhunpo Monastery, near Shigatse.

78. The courtyard of the Jokhang Temple, Lhasa.

79. Tibetan monks in exile in Kathmandu, Nepal.

80. Mother and child at Tsang Kung Monastery, Lhasa.

81. Fabric shop in Lhasa.

82. The village around Tsurphu Monastery.

83. Villages around Tsurphu Monastery.

84. Kambala Pass.

85. Villagers climbing to Drek Yerpa Caves.

86. A mother carries her baby on the back as she walks through fields in Tsedang.

87. Samye Monastery.

88. Restoration work at Samye Monastery.

89. Polkhor Monastery, Gyantse.

90. Dzong Fortress, Gyantse.

91. Tsedang.

92. Entrance to Mindroling Monastery. This was one of the earliest monasteries founded in the 10th century and reconstructed in the 17th century.

93. At Lhasa Tsang Kung nunnery in Lhasa, female monks go through their daily prayers and chanting.

94. Kambala Pass.

95. Lablunga Pass. Note the tiny white motor car in the lower far right corner.

96. Young boy at Mindroling Monastery.

97. Keeper of a nunnery in Tsedang with his prayer beads.

98. Crossing the Brahmaputra.

99. On the way to Samye Monastery a woman says her daily prayers on board at the boat.

100. Shop in Gyantse.

101. In the Barkhor, dried and powdered herbs (juniper) for burning are sold.

102. Print shop where they make prayer rolls in Tsang Kung Monastery, Lhasa.

103. A woman receives tea in Drepung Monastery.

104. The main hall in Tsurphu Monastery.

105. In the inner courtyard of the Jokhang Temple, a father helps his son and an elderly man at the pump.

106. Monks do a Tara Puja in Samye Monastery.

107. Candles in the Jokhang, Lhasa.

108. Young child at Mindroling Monastery.

109. Offerings of fruit and biscuits, Tsang Kung Monastery.

110. Tashilhunpo Monastery, Shigatse.

111. A monk pours water over worshippers' heads at Tashilhunpo Monastery, Shigatse.

112. Afternoon light sets a room aglow at a nunnery in Tsedang. Each great monastery in Tibet once possessed giant silk applique hangings.

113. Mindroling Monastery.

114. Restoration work at Samye Monastery.

115–116. Yambulakhalang Palace, Tsedang.

117. Woman on the road, Tsedang.

118. Offerings such as khatas (ceremonial scarves), seeds and money are left along with charm boxes (amulets) during visits to monasteries and shrines.

119. Monks prepare thermoses of tea at Drepung Monastery, Lhasa.

120. A ten-year-old monk at Tsurphu Monastery. Dating back to 1187, the monastery has undergone major restoration and rebuilding efforts since the Chinese invasion of Tibet destroyed it in 1959. It is here that the 17th Karmapa was enthroned in September 1992.

121. The printing room in Tsang Kung Monastery, Lhasa.

122. Protector chapels at Tsurphu Monastery.

123. Monks' rooms in Samye Monastery.

124. Rooftop of Tsang Kung Monastery.

125. Tsang Kung Monastery, Lhasa.

126. His Highness, the 17th Karmapa, Tsurphu Monastery.

127. His Highness, the 17th Karmapa, waves from the window of his room in Tsurphu Monastery.

128. Approximately 350 kilometers south of Lhasa, and 4,800 meters above sea level, the terrain becomes rugged and mountainous.

129. Mani stones, Shigatse.

130. A stupa around Samye Monastery.

131. Mt. Everest is just visible through the clouds as a horse-drawn cart makes its way across the valley.

132. Prayer flags at Ultringway.

133. Samye.

134. Yaks, pedestrians and a few vehicles are daily sights outside of the Potala Palace, perched high above Lhasa. It is 118 meters high and has 1,000 rooms.

135. Nyalam Pass.

136. Rock carvings of the Sakyamuni Buddha outside of Lhasa.

137. Construction at Samye Monastery.

138–139. Drek Yerpa.

Biography

Fiona McDougall was born in 1954 in Melbourne, Australia. She studied Graphic Art at Swinburne College of Advanced Education and worked as the first woman photographer on Australia's leading daily newspaper, *The Age*.

In 1983, Ms. McDougall moved to Rome where she worked as a freelance photojournalist for six years, also traveling to Indonesia, Bangladesh, Sudan, Nepal, Nigeria and Ethiopia on assignments for United Nations Food and Agricultural Organization and the World Food Program.

Ms. McDougall moved to Nairobi, Kenya, in 1989 with her husband, Jonathan Villet, and their 5-month-old twins, Dominic and Raphael. There she continued to freelance for United Nations agencies and magazines such as *Time* and *Newsweek*. *The New York Times* nominated her for the Pulitzer Prize for her outstanding photographic coverage of Somalia during its internal conflict in 1992. She also served as photo editor for *The Nation* newspaper in Nairobi, helping to train staff photographers. In 1991, a collection of her portraits of well-known people in the arts and politics of Kenya

Jason Doty

was exhibited at the Gallery Watatu in Nairobi.

In 1995 she and her family briefly returned to San Francisco before moving to Harare, Zimbabwe, where her husband ran a communications project for the United Nations. She continued her freelance work for international magazines and newspapers and UN agencies. From Harare, she accompanied Buddhists from the southern Africa region to Tibet and took the photographs seen in this book. This work was first shown in Harare to raise money for a clinic in Lhasa. She also exhibited her work on the Tonga people of northern Zimbabwe.

She and the family returned to San Francisco in 1998. She is currently a managing partner of OneWorld Communications, Inc., a San Francisco firm specializing in assisting non-profit organizations and government agencies with marketing, media production and public information campaigns. Ms. McDougall is also the photo editor for a Bay Area newspaper. Her work on Tibet was exhibited in April 2000 at San Francisco City Hall.